Foreword

"Probably one of the best things about Duane Barnhart's book is his emphasis upon the fun and joy of cartooning. I don't think anyone can deny that there are times when it is extremely hard work and takes total dedication. I do believe, however, that drawing funny pictures, whether for newspapers or simply on a letter to a friend, can be wonderfully satisfying. Duane Barnhart leads you, in his writing and cartoon samples, to the sort of start that everyone, who wishes to draw cartoons, certainly needs."

Charles M. Schulz
Creator of Peanuts

CONTENTS

CONTENTS

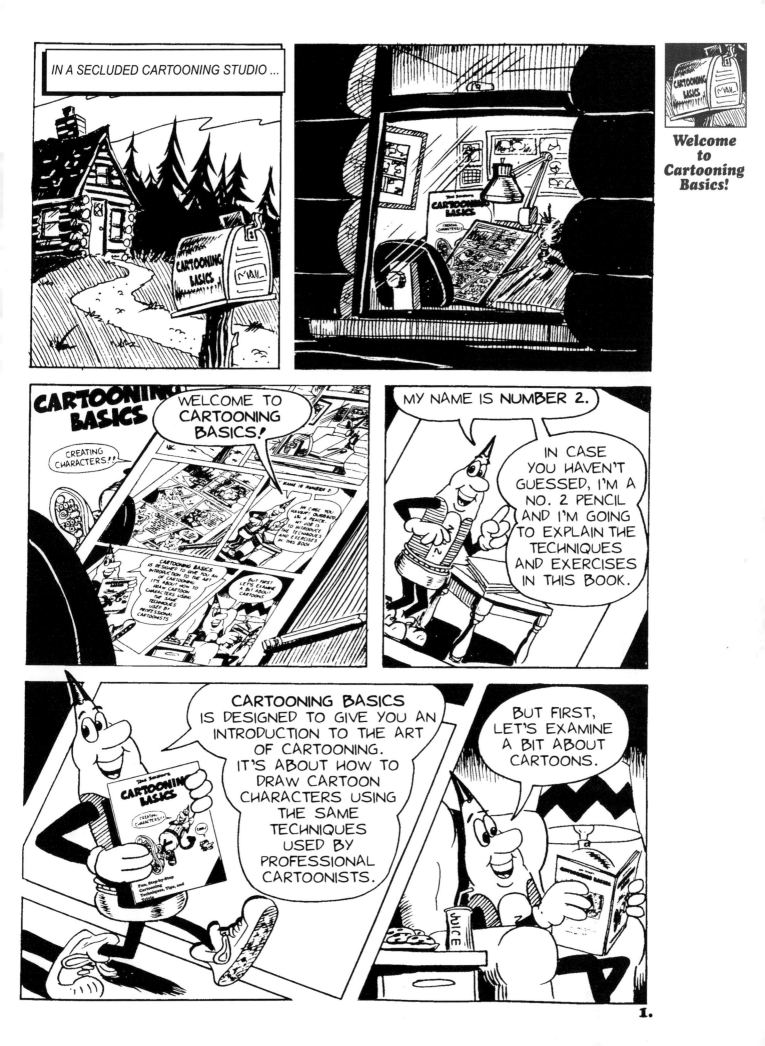

IN A SECLUDED CARTOONING STUDIO ...

Welcome to Cartooning Basics!

WELCOME TO CARTOONING BASICS!

CREATING CHARACTERS!!

MY NAME IS NUMBER 2.

IN CASE YOU HAVEN'T GUESSED, I'M A NO. 2 PENCIL AND I'M GOING TO EXPLAIN THE TECHNIQUES AND EXERCISES IN THIS BOOK.

CARTOONING BASICS IS DESIGNED TO GIVE YOU AN INTRODUCTION TO THE ART OF CARTOONING. IT'S ABOUT HOW TO DRAW CARTOON CHARACTERS USING THE SAME TECHNIQUES USED BY PROFESSIONAL CARTOONISTS.

BUT FIRST, LET'S EXAMINE A BIT ABOUT CARTOONS.

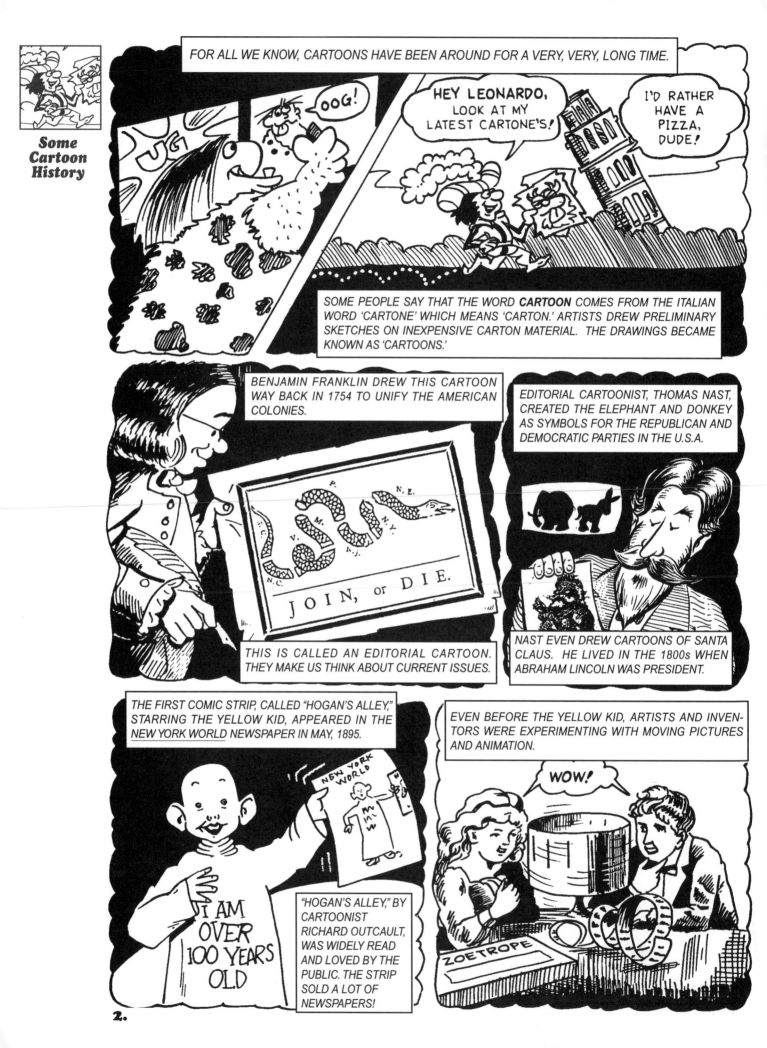

FOR ALL WE KNOW, CARTOONS HAVE BEEN AROUND FOR A VERY, VERY, LONG TIME.

OOG!

HEY LEONARDO, LOOK AT MY LATEST CARTONE'S!

I'D RATHER HAVE A PIZZA, DUDE!

SOME PEOPLE SAY THAT THE WORD **CARTOON** COMES FROM THE ITALIAN WORD 'CARTONE' WHICH MEANS 'CARTON.' ARTISTS DREW PRELIMINARY SKETCHES ON INEXPENSIVE CARTON MATERIAL. THE DRAWINGS BECAME KNOWN AS 'CARTOONS.'

BENJAMIN FRANKLIN DREW THIS CARTOON WAY BACK IN 1754 TO UNIFY THE AMERICAN COLONIES.

EDITORIAL CARTOONIST, THOMAS NAST, CREATED THE ELEPHANT AND DONKEY AS SYMBOLS FOR THE REPUBLICAN AND DEMOCRATIC PARTIES IN THE U.S.A.

JOIN, or DIE.

THIS IS CALLED AN EDITORIAL CARTOON. THEY MAKE US THINK ABOUT CURRENT ISSUES.

NAST EVEN DREW CARTOONS OF SANTA CLAUS. HE LIVED IN THE 1800s WHEN ABRAHAM LINCOLN WAS PRESIDENT.

THE FIRST COMIC STRIP, CALLED "HOGAN'S ALLEY," STARRING THE YELLOW KID, APPEARED IN THE NEW YORK WORLD NEWSPAPER IN MAY, 1895.

EVEN BEFORE THE YELLOW KID, ARTISTS AND INVENTORS WERE EXPERIMENTING WITH MOVING PICTURES AND ANIMATION.

WOW!

NEW YORK WORLD

I AM OVER 100 YEARS OLD

"HOGAN'S ALLEY," BY CARTOONIST RICHARD OUTCAULT, WAS WIDELY READ AND LOVED BY THE PUBLIC. THE STRIP SOLD A LOT OF NEWSPAPERS!

ZOETROPE

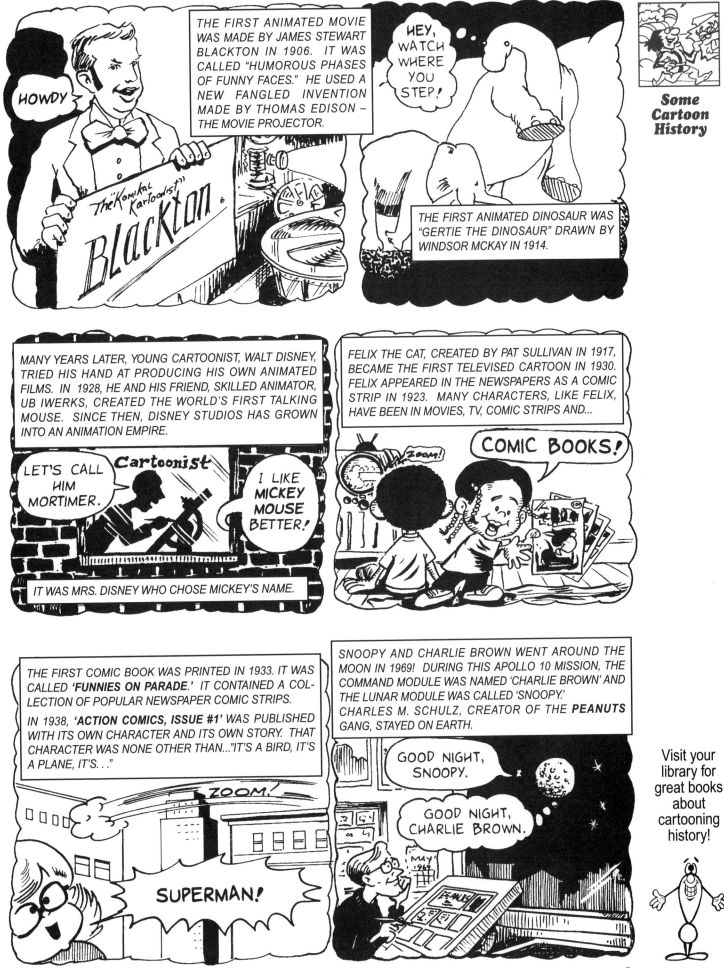

HOWDY

THE FIRST ANIMATED MOVIE WAS MADE BY JAMES STEWART BLACKTON IN 1906. IT WAS CALLED "HUMOROUS PHASES OF FUNNY FACES." HE USED A NEW FANGLED INVENTION MADE BY THOMAS EDISON – THE MOVIE PROJECTOR.

The "Komikal Kartoonist" Blackton

HEY, WATCH WHERE YOU STEP!

THE FIRST ANIMATED DINOSAUR WAS "GERTIE THE DINOSAUR" DRAWN BY WINDSOR MCKAY IN 1914.

Some Cartoon History

MANY YEARS LATER, YOUNG CARTOONIST, WALT DISNEY, TRIED HIS HAND AT PRODUCING HIS OWN ANIMATED FILMS. IN 1928, HE AND HIS FRIEND, SKILLED ANIMATOR, UB IWERKS, CREATED THE WORLD'S FIRST TALKING MOUSE. SINCE THEN, DISNEY STUDIOS HAS GROWN INTO AN ANIMATION EMPIRE.

LET'S CALL HIM MORTIMER.

Cartoonist

I LIKE MICKEY MOUSE BETTER!

IT WAS MRS. DISNEY WHO CHOSE MICKEY'S NAME.

FELIX THE CAT, CREATED BY PAT SULLIVAN IN 1917, BECAME THE FIRST TELEVISED CARTOON IN 1930. FELIX APPEARED IN THE NEWSPAPERS AS A COMIC STRIP IN 1923. MANY CHARACTERS, LIKE FELIX, HAVE BEEN IN MOVIES, TV, COMIC STRIPS AND...

ZOOM!

COMIC BOOKS!

THE FIRST COMIC BOOK WAS PRINTED IN 1933. IT WAS CALLED **'FUNNIES ON PARADE.'** IT CONTAINED A COL-LECTION OF POPULAR NEWSPAPER COMIC STRIPS.

IN 1938, **'ACTION COMICS, ISSUE #1'** WAS PUBLISHED WITH ITS OWN CHARACTER AND ITS OWN STORY. THAT CHARACTER WAS NONE OTHER THAN..."IT'S A BIRD, IT'S A PLANE, IT'S. . ."

ZOOM!

SUPERMAN!

SNOOPY AND CHARLIE BROWN WENT AROUND THE MOON IN 1969! DURING THIS APOLLO 10 MISSION, THE COMMAND MODULE WAS NAMED 'CHARLIE BROWN' AND THE LUNAR MODULE WAS CALLED 'SNOOPY.'
CHARLES M. SCHULZ, CREATOR OF THE **PEANUTS** GANG, STAYED ON EARTH.

GOOD NIGHT, SNOOPY.

GOOD NIGHT, CHARLIE BROWN.

Visit your library for great books about cartooning history!

3.

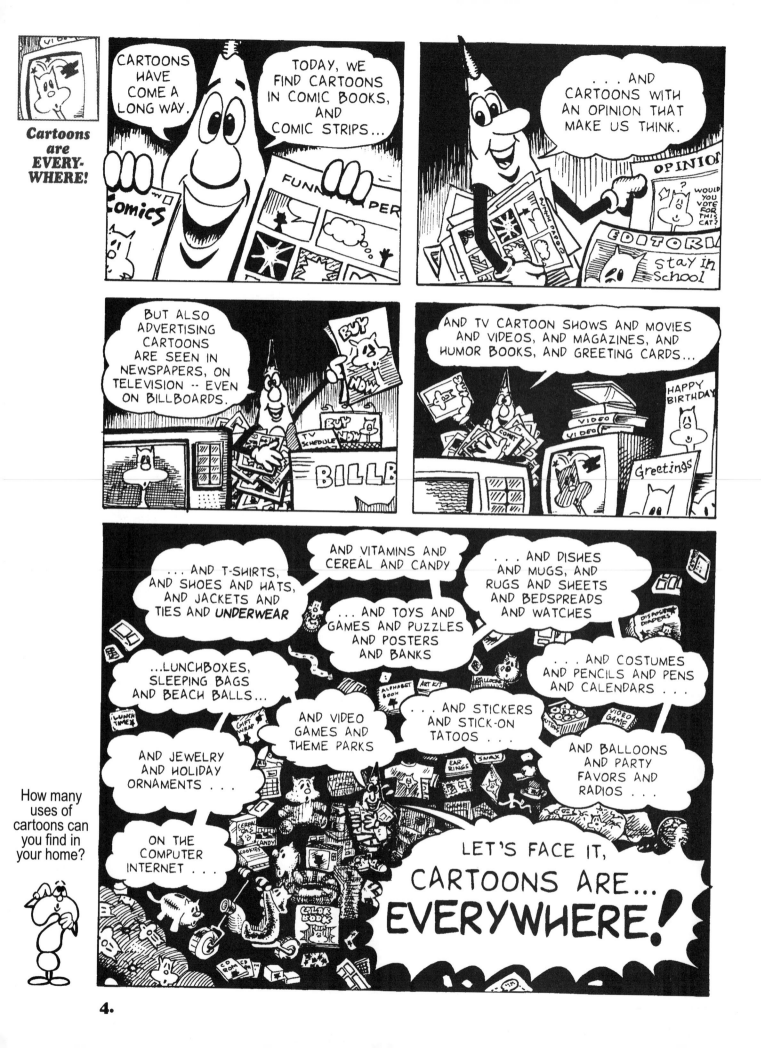

Cartoons are EVERYWHERE!

How many uses of cartoons can you find in your home?

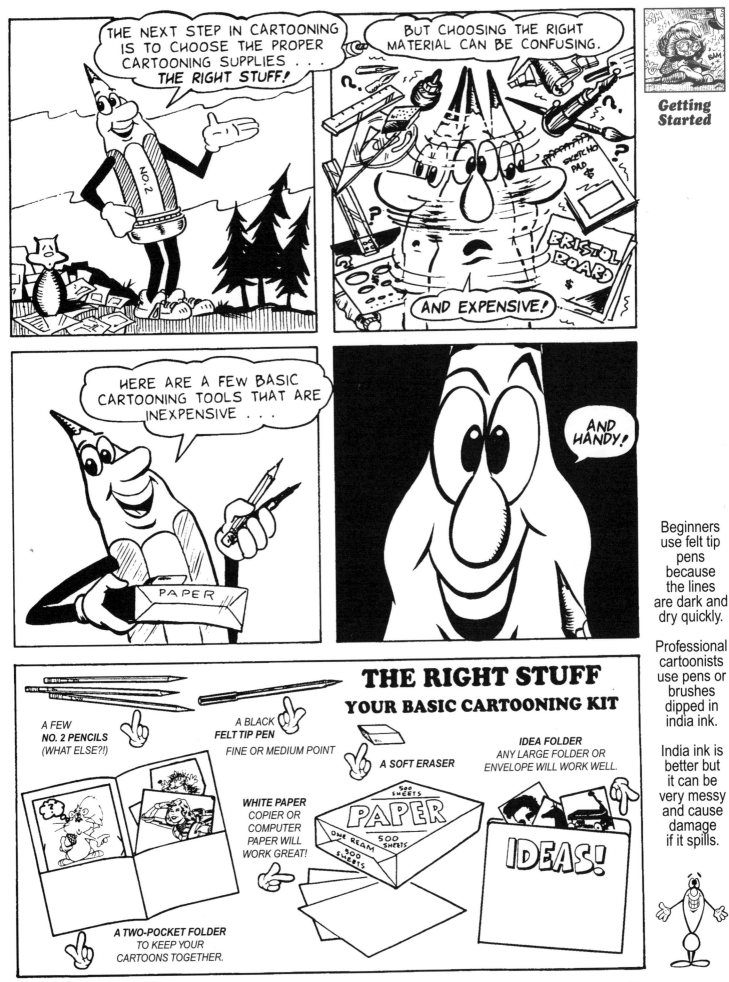

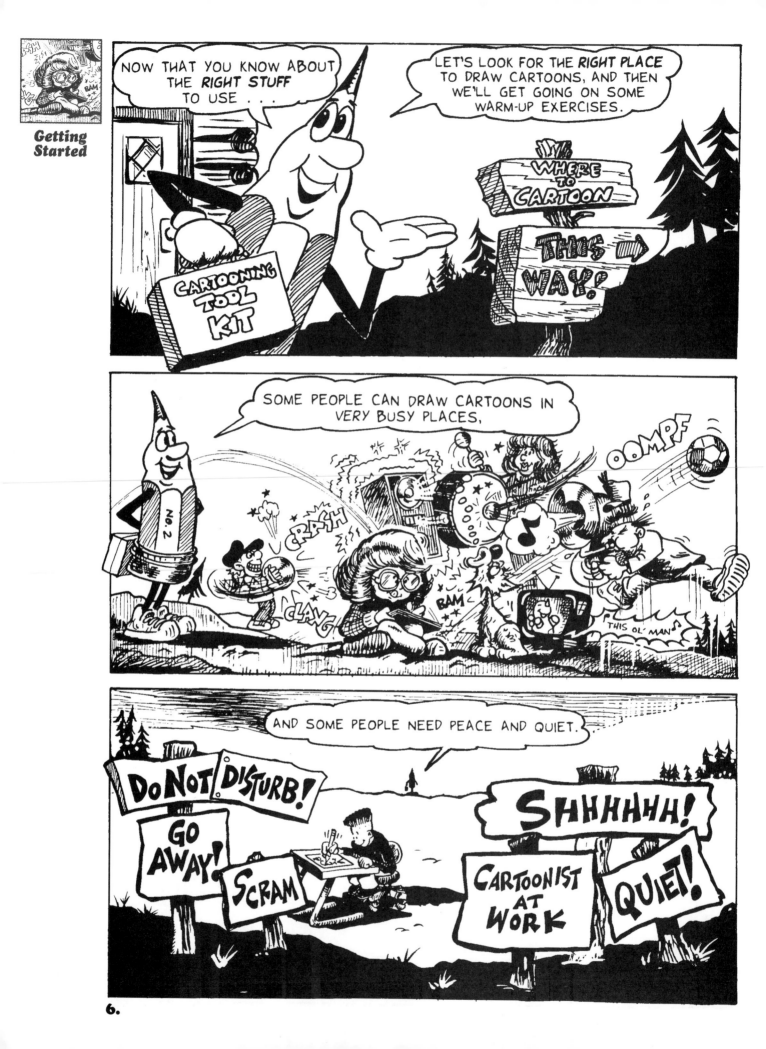

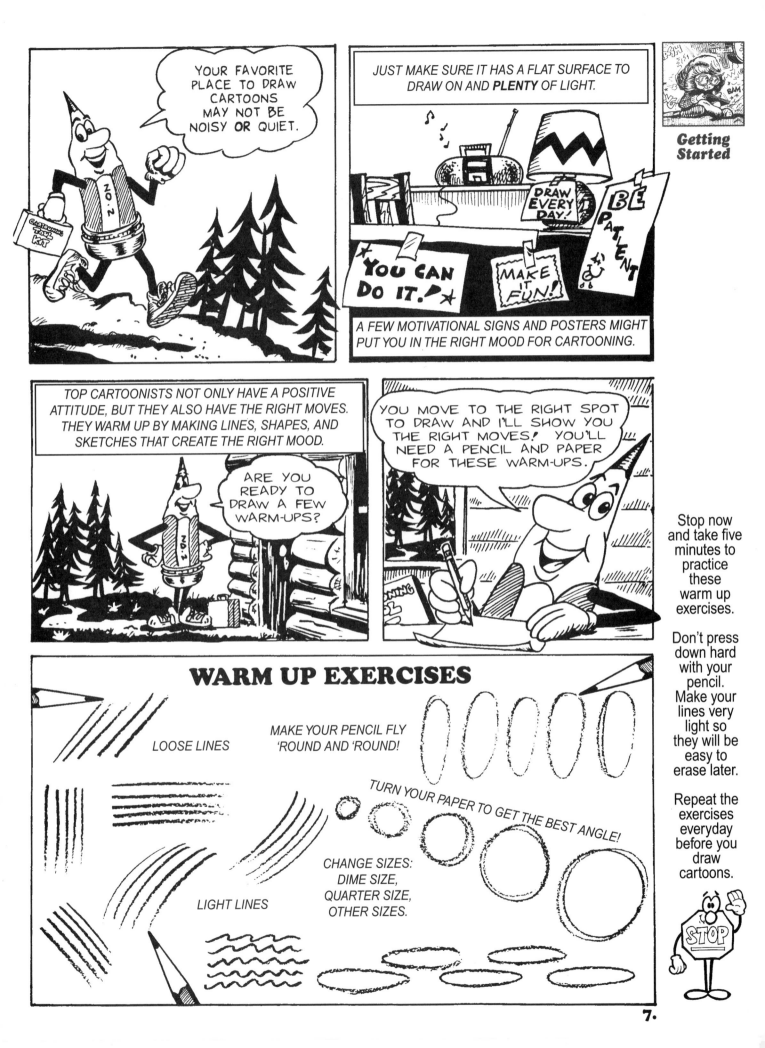

YOUR FAVORITE PLACE TO DRAW CARTOONS MAY NOT BE NOISY **OR** QUIET.

JUST MAKE SURE IT HAS A FLAT SURFACE TO DRAW ON AND **PLENTY** OF LIGHT.

DRAW EVERY DAY!

BE PATIENT

YOU CAN DO IT!

MAKE IT FUN!

A FEW MOTIVATIONAL SIGNS AND POSTERS MIGHT PUT YOU IN THE RIGHT MOOD FOR CARTOONING.

TOP CARTOONISTS NOT ONLY HAVE A POSITIVE ATTITUDE, BUT THEY ALSO HAVE THE RIGHT MOVES. THEY WARM UP BY MAKING LINES, SHAPES, AND SKETCHES THAT CREATE THE RIGHT MOOD.

ARE YOU READY TO DRAW A FEW WARM-UPS?

YOU MOVE TO THE RIGHT SPOT TO DRAW AND I'LL SHOW YOU THE RIGHT MOVES! YOU'LL NEED A PENCIL AND PAPER FOR THESE WARM-UPS.

Stop now and take five minutes to practice these warm up exercises.

Don't press down hard with your pencil. Make your lines very light so they will be easy to erase later.

Repeat the exercises everyday before you draw cartoons.

WARM UP EXERCISES

LOOSE LINES

MAKE YOUR PENCIL FLY 'ROUND AND 'ROUND!

TURN YOUR PAPER TO GET THE BEST ANGLE!

CHANGE SIZES: DIME SIZE, QUARTER SIZE, OTHER SIZES.

LIGHT LINES

STOP

7.

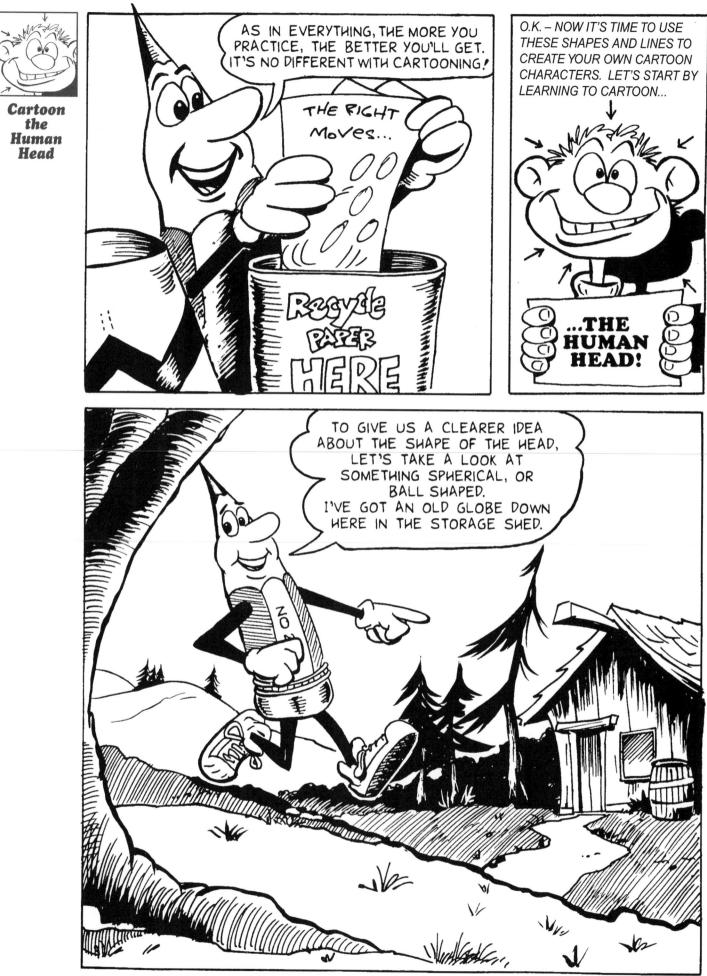

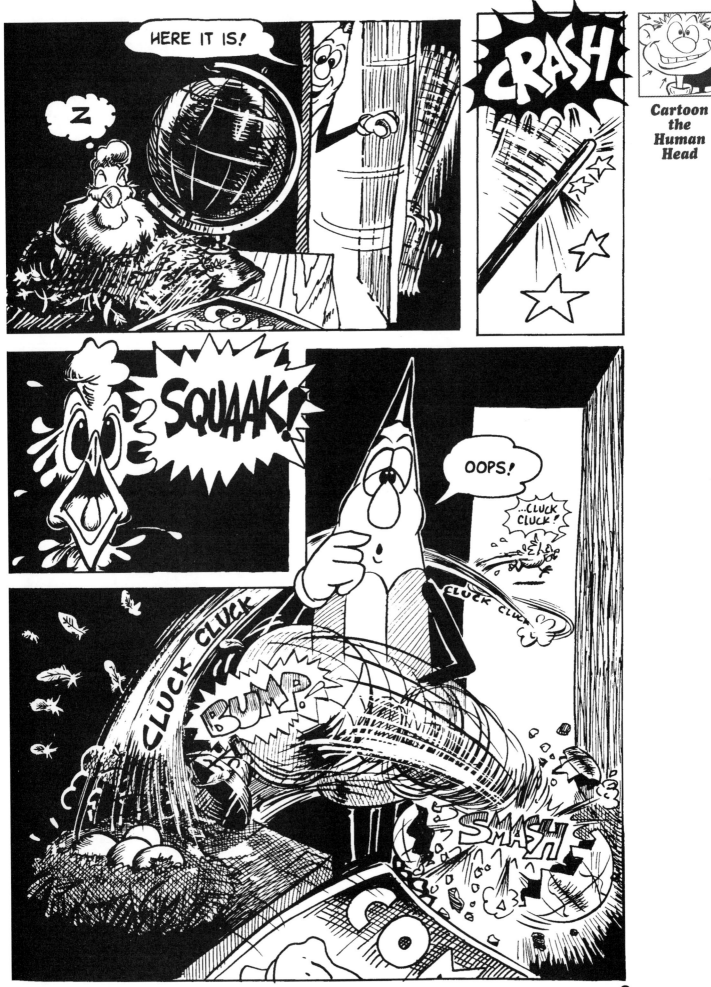

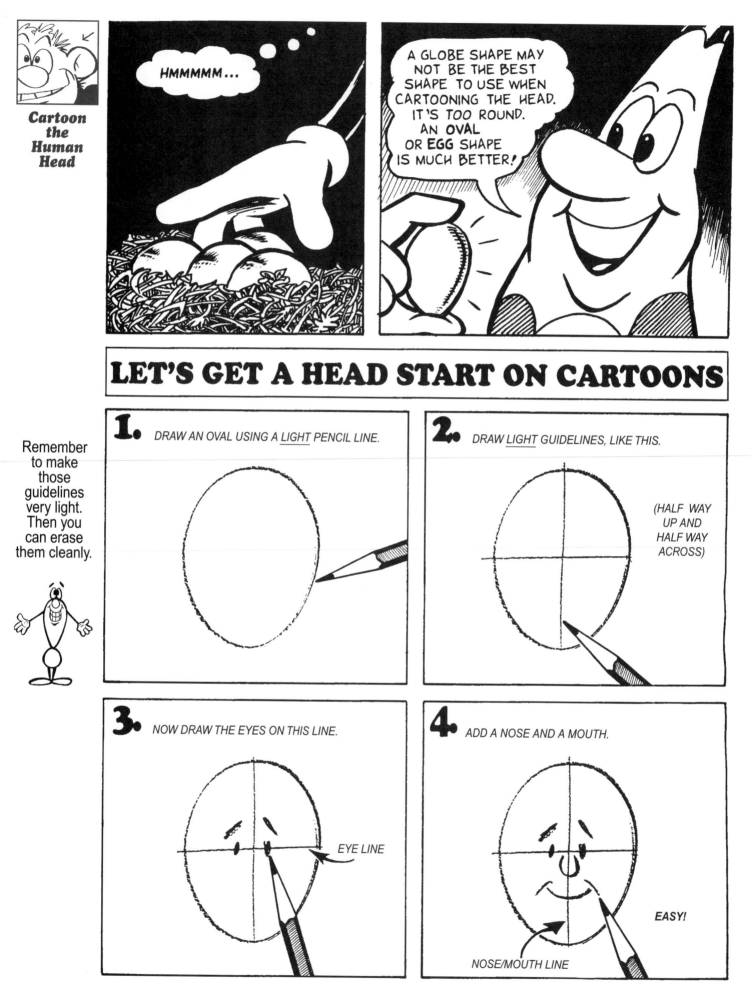

HMMMMM...

A GLOBE SHAPE MAY NOT BE THE BEST SHAPE TO USE WHEN CARTOONING THE HEAD. IT'S *TOO* ROUND. AN **OVAL** OR **EGG** SHAPE IS MUCH BETTER!

LET'S GET A HEAD START ON CARTOONS

Remember to make those guidelines very light. Then you can erase them cleanly.

1. *DRAW AN OVAL USING A <u>LIGHT</u> PENCIL LINE.*

2. *DRAW <u>LIGHT</u> GUIDELINES, LIKE THIS.*

(HALF WAY UP AND HALF WAY ACROSS)

3. *NOW DRAW THE EYES ON THIS LINE.*

EYE LINE

4. *ADD A NOSE AND A MOUTH.*

EASY!

NOSE/MOUTH LINE

10.

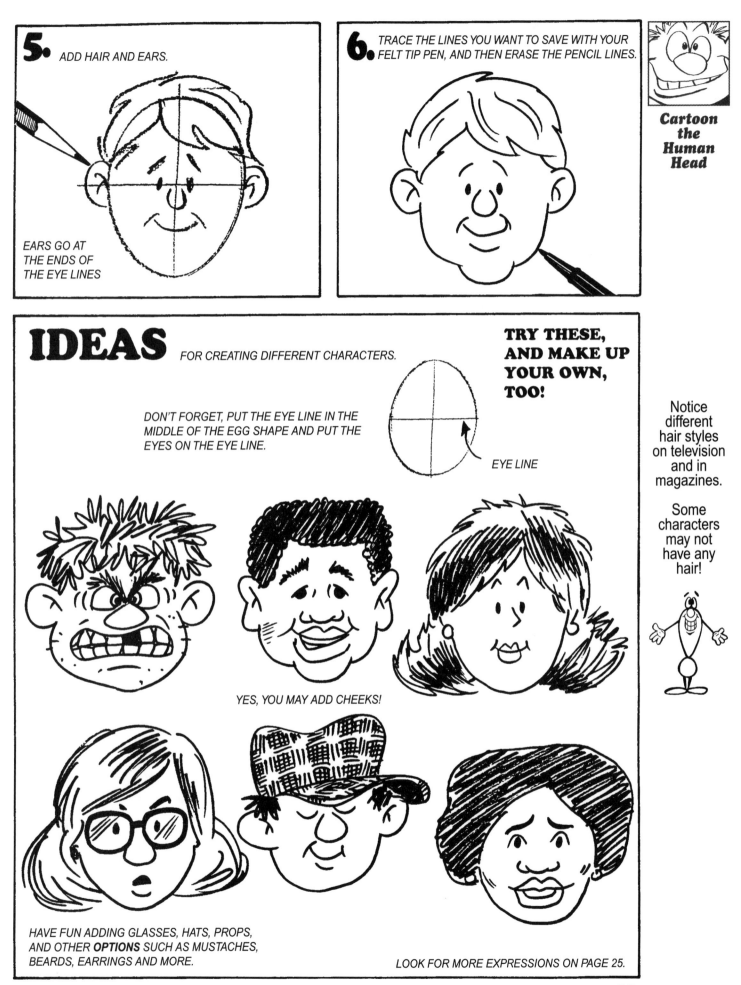

5. ADD HAIR AND EARS.

EARS GO AT THE ENDS OF THE EYE LINES

6. TRACE THE LINES YOU WANT TO SAVE WITH YOUR FELT TIP PEN, AND THEN ERASE THE PENCIL LINES.

Cartoon the Human Head

IDEAS FOR CREATING DIFFERENT CHARACTERS.

TRY THESE, AND MAKE UP YOUR OWN, TOO!

DON'T FORGET, PUT THE EYE LINE IN THE MIDDLE OF THE EGG SHAPE AND PUT THE EYES ON THE EYE LINE.

EYE LINE

Notice different hair styles on television and in magazines.

Some characters may not have any hair!

YES, YOU MAY ADD CHEEKS!

HAVE FUN ADDING GLASSES, HATS, PROPS, AND OTHER **OPTIONS** SUCH AS MUSTACHES, BEARDS, EARRINGS AND MORE.

LOOK FOR MORE EXPRESSIONS ON PAGE 25.

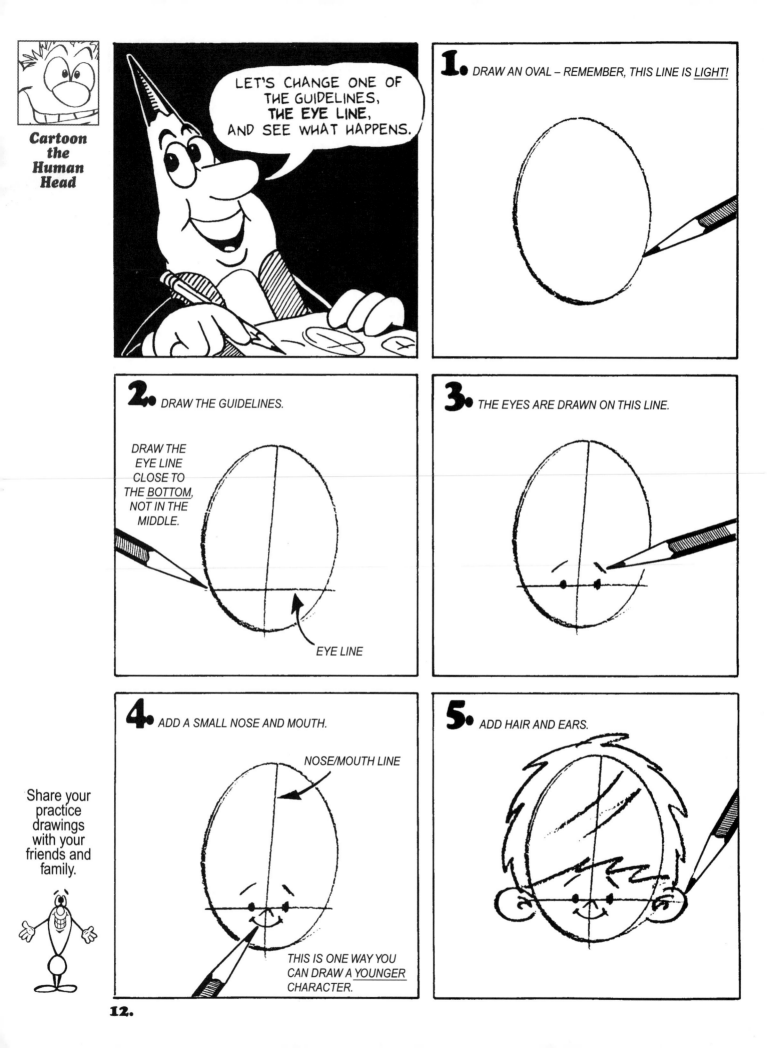

Cartoon the Human Head

LET'S CHANGE ONE OF THE GUIDELINES, **THE EYE LINE,** AND SEE WHAT HAPPENS.

1. *DRAW AN OVAL – REMEMBER, THIS LINE IS LIGHT!*

2. *DRAW THE GUIDELINES.*

DRAW THE EYE LINE CLOSE TO THE BOTTOM, NOT IN THE MIDDLE.

EYE LINE

3. *THE EYES ARE DRAWN ON THIS LINE.*

4. *ADD A SMALL NOSE AND MOUTH.*

NOSE/MOUTH LINE

THIS IS ONE WAY YOU CAN DRAW A YOUNGER CHARACTER.

5. *ADD HAIR AND EARS.*

Share your practice drawings with your friends and family.

12.

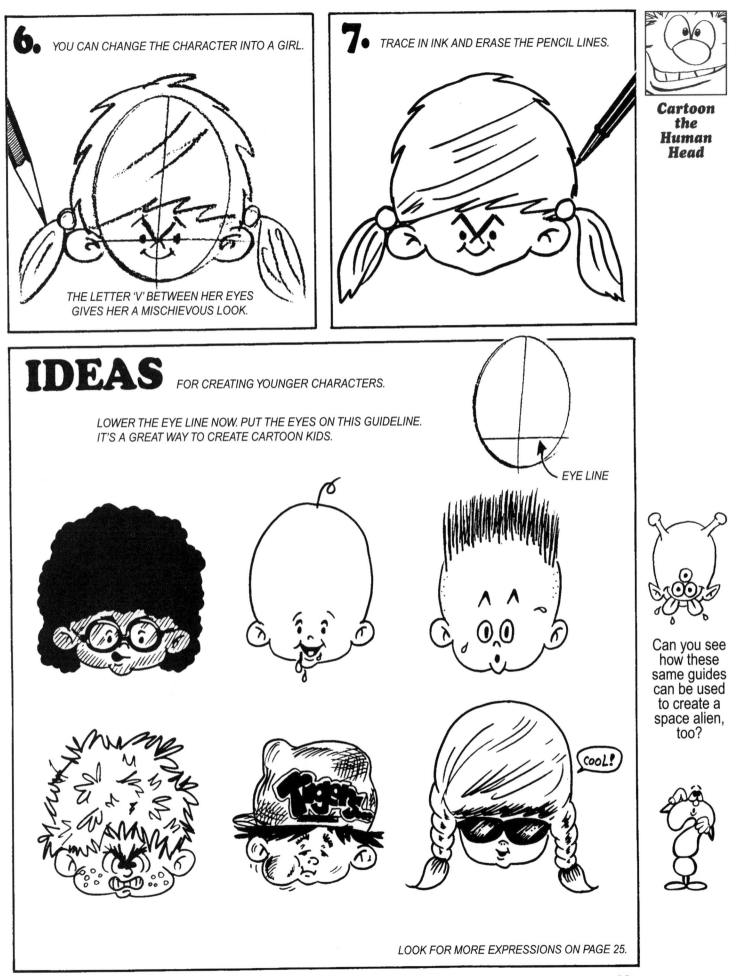

6. YOU CAN CHANGE THE CHARACTER INTO A GIRL.

THE LETTER 'V' BETWEEN HER EYES GIVES HER A MISCHIEVOUS LOOK.

7. TRACE IN INK AND ERASE THE PENCIL LINES.

Cartoon the Human Head

IDEAS FOR CREATING YOUNGER CHARACTERS.

LOWER THE EYE LINE NOW. PUT THE EYES ON THIS GUIDELINE. IT'S A GREAT WAY TO CREATE CARTOON KIDS.

EYE LINE

Can you see how these same guides can be used to create a space alien, too?

COOL!

LOOK FOR MORE EXPRESSIONS ON PAGE 25.

13.

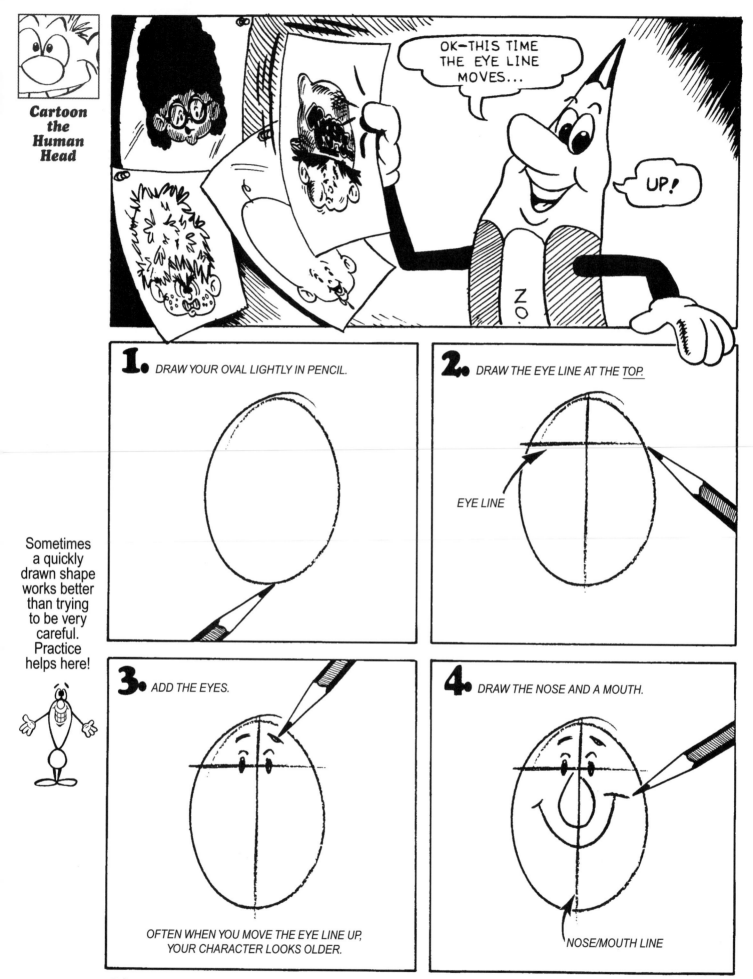

Cartoon the Human Head

Sometimes a quickly drawn shape works better than trying to be very careful. Practice helps here!

OK–THIS TIME THE EYE LINE MOVES...

UP!

1. DRAW YOUR OVAL LIGHTLY IN PENCIL.

2. DRAW THE EYE LINE AT THE TOP.

EYE LINE

3. ADD THE EYES.

OFTEN WHEN YOU MOVE THE EYE LINE UP, YOUR CHARACTER LOOKS OLDER.

4. DRAW THE NOSE AND A MOUTH.

NOSE/MOUTH LINE

14.

5. *EARS AND HAIR ARE NEXT.*

6. *FINISH BY TRACING WITH YOUR FELT TIP PEN. NEXT, ERASE YOUR PENCIL LINES.*

Cartoon the Human Head

IDEAS *FOR CREATING MORE CHARACTERS.*

PUT THE EYE LINE HIGHER ON THE EGG SHAPE AND DRAW THE CARTOON CHARACTER'S EYES ON THAT LINE.

EYE LINE

With different size eyes, noses and mouths, your character will change age more easily.

Now that you can change the ages of your characters, stop and try a cartoon family of different aged people.

USE YOUR IMAGINATION! LOOK IN MAGAZINES AND BOOKS TO GET IDEAS FOR CHARACTERS.

FOR MORE EXPRESSIONS, TURN TO PAGE 25.

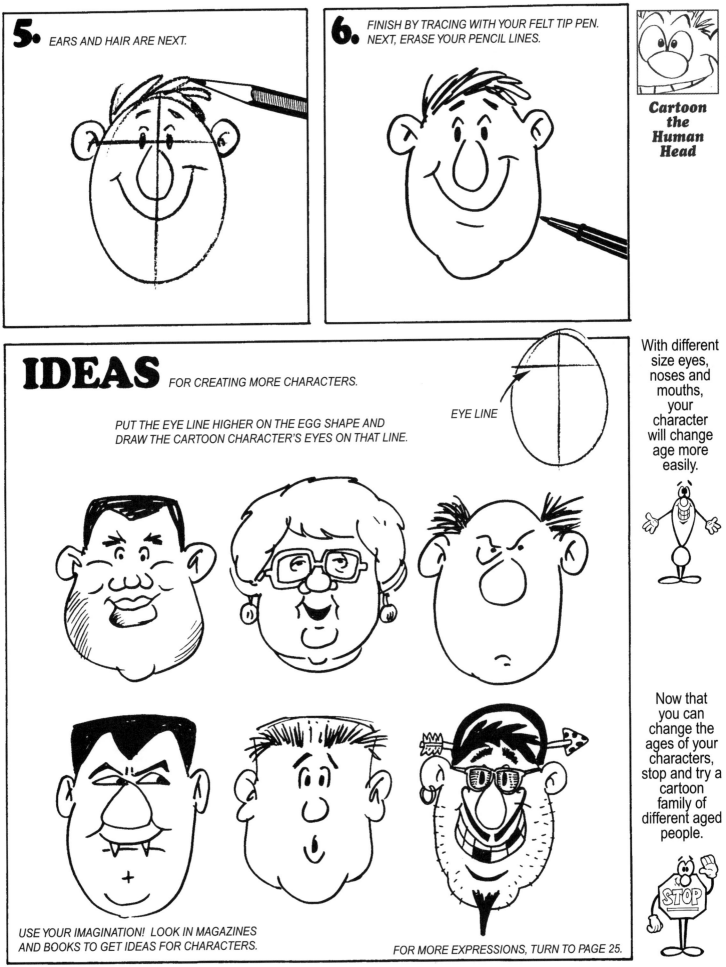

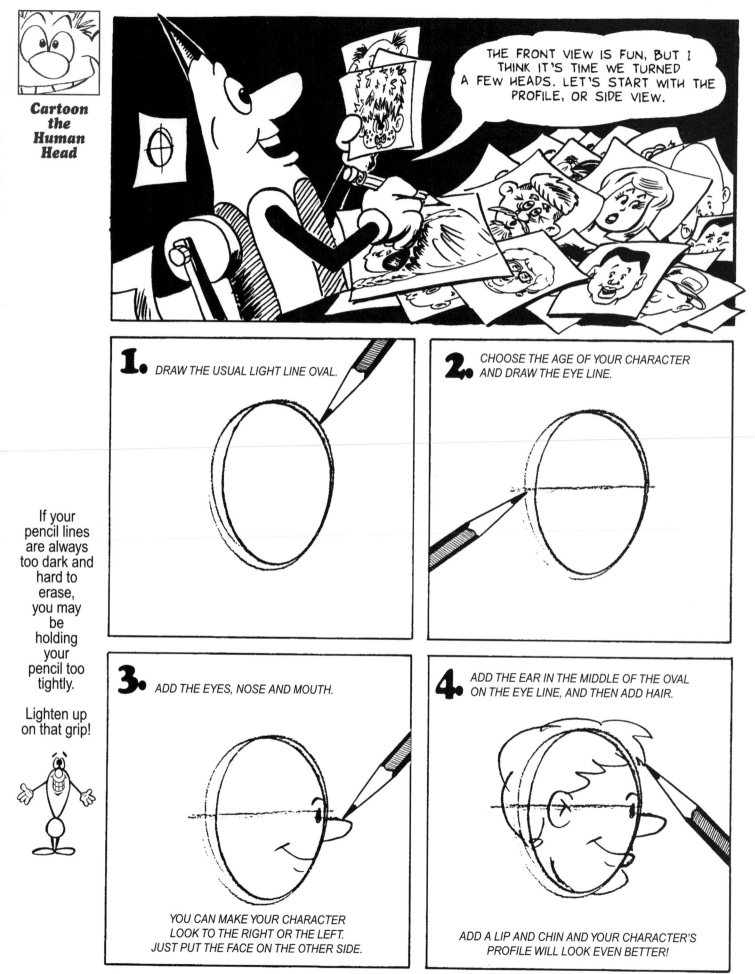

Cartoon the Human Head

THE FRONT VIEW IS FUN, BUT I THINK IT'S TIME WE TURNED A FEW HEADS. LET'S START WITH THE PROFILE, OR SIDE VIEW.

If your pencil lines are always too dark and hard to erase, you may be holding your pencil too tightly.

Lighten up on that grip!

1. DRAW THE USUAL LIGHT LINE OVAL.

2. CHOOSE THE AGE OF YOUR CHARACTER AND DRAW THE EYE LINE.

3. ADD THE EYES, NOSE AND MOUTH.

YOU CAN MAKE YOUR CHARACTER LOOK TO THE RIGHT OR THE LEFT. JUST PUT THE FACE ON THE OTHER SIDE.

4. ADD THE EAR IN THE MIDDLE OF THE OVAL ON THE EYE LINE, AND THEN ADD HAIR.

ADD A LIP AND CHIN AND YOUR CHARACTER'S PROFILE WILL LOOK EVEN BETTER!

16.

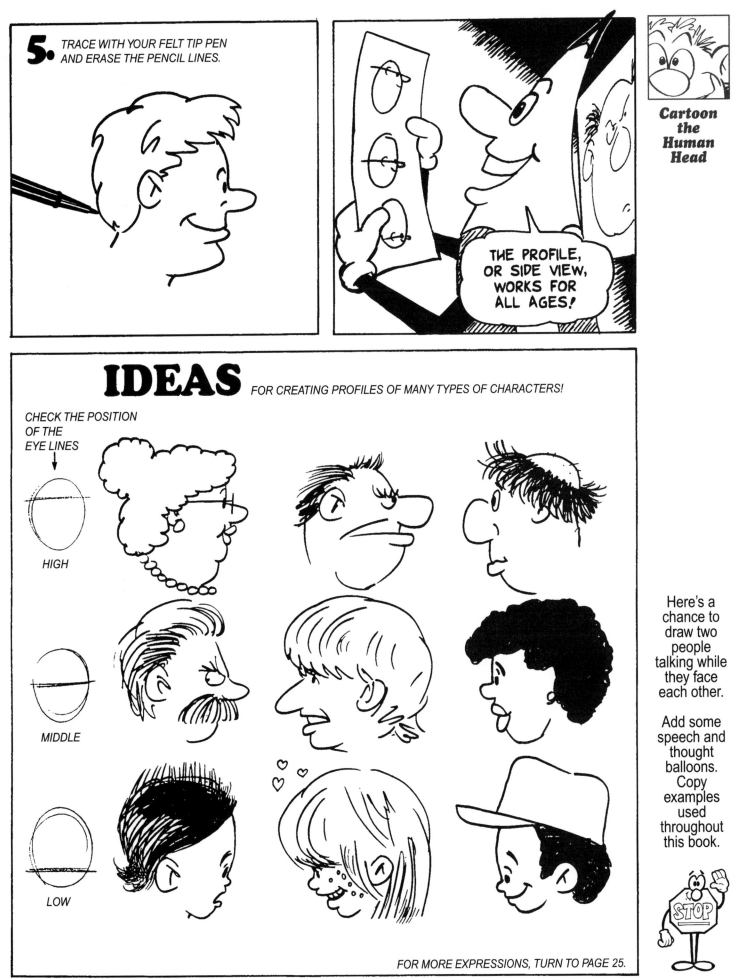

5. TRACE WITH YOUR FELT TIP PEN AND ERASE THE PENCIL LINES.

THE PROFILE, OR SIDE VIEW, WORKS FOR ALL AGES!

Cartoon the Human Head

IDEAS FOR CREATING PROFILES OF MANY TYPES OF CHARACTERS!

CHECK THE POSITION OF THE EYE LINES

HIGH

MIDDLE

LOW

Here's a chance to draw two people talking while they face each other.

Add some speech and thought balloons. Copy examples used throughout this book.

FOR MORE EXPRESSIONS, TURN TO PAGE 25.

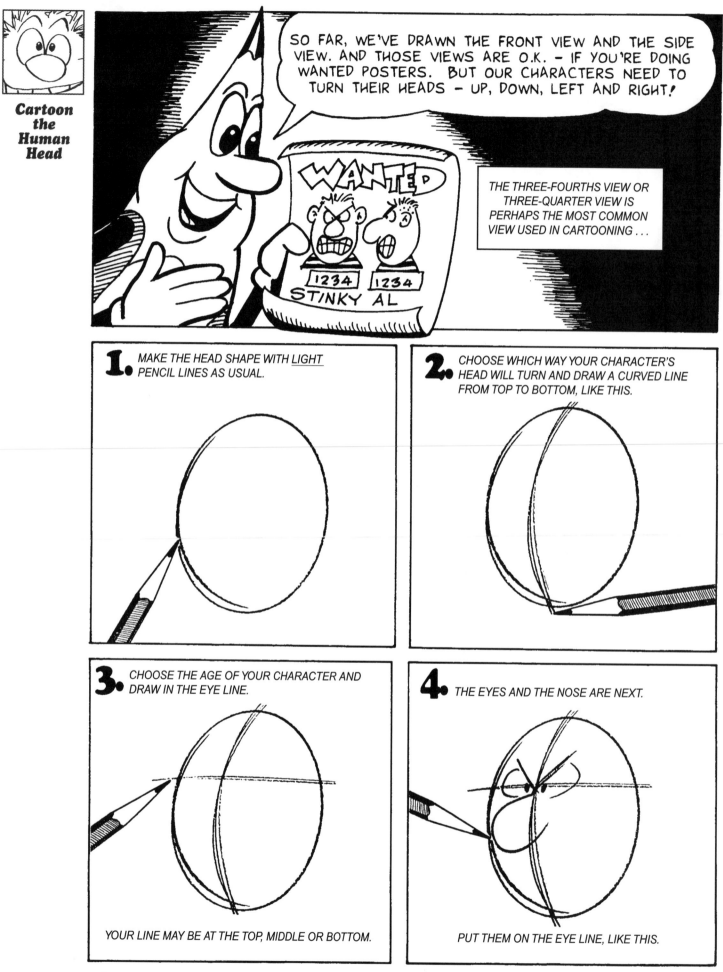

Cartoon the Human Head

SO FAR, WE'VE DRAWN THE FRONT VIEW AND THE SIDE VIEW. AND THOSE VIEWS ARE O.K. – IF YOU'RE DOING WANTED POSTERS. BUT OUR CHARACTERS NEED TO TURN THEIR HEADS – UP, DOWN, LEFT AND RIGHT!

WANTED

1234 1234

STINKY AL

THE THREE-FOURTHS VIEW OR THREE-QUARTER VIEW IS PERHAPS THE MOST COMMON VIEW USED IN CARTOONING . . .

1. *MAKE THE HEAD SHAPE WITH <u>LIGHT</u> PENCIL LINES AS USUAL.*

2. *CHOOSE WHICH WAY YOUR CHARACTER'S HEAD WILL TURN AND DRAW A CURVED LINE FROM TOP TO BOTTOM, LIKE THIS.*

3. *CHOOSE THE AGE OF YOUR CHARACTER AND DRAW IN THE EYE LINE.*

YOUR LINE MAY BE AT THE TOP, MIDDLE OR BOTTOM.

4. *THE EYES AND THE NOSE ARE NEXT.*

PUT THEM ON THE EYE LINE, LIKE THIS.

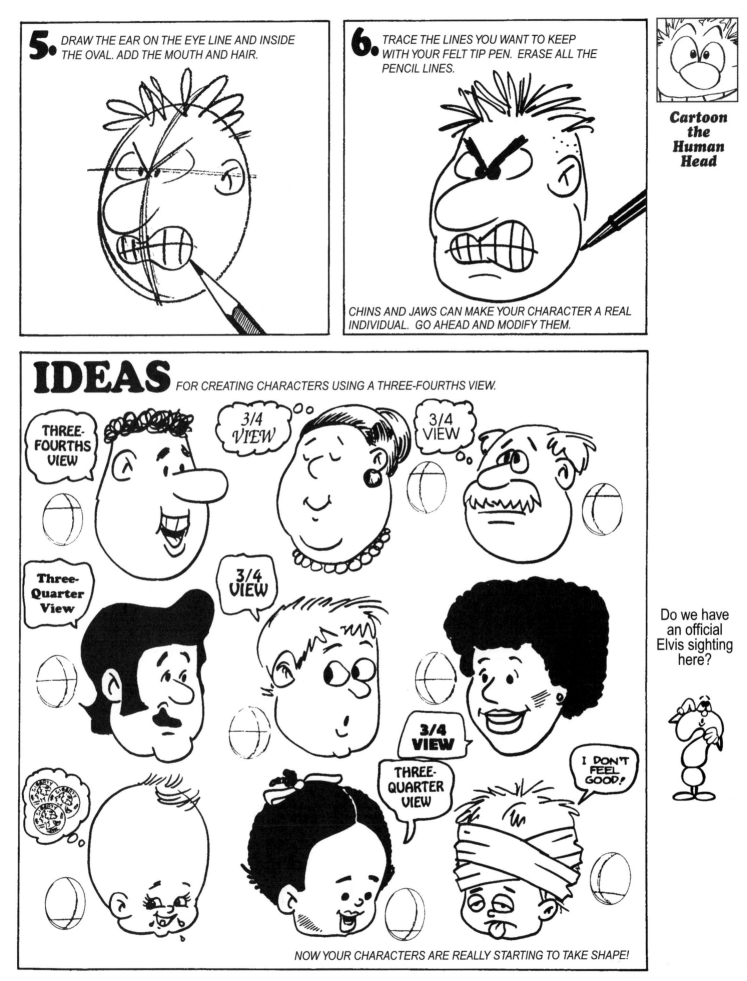

5. DRAW THE EAR ON THE EYE LINE AND INSIDE THE OVAL. ADD THE MOUTH AND HAIR.

6. TRACE THE LINES YOU WANT TO KEEP WITH YOUR FELT TIP PEN. ERASE ALL THE PENCIL LINES.

CHINS AND JAWS CAN MAKE YOUR CHARACTER A REAL INDIVIDUAL. GO AHEAD AND MODIFY THEM.

Cartoon the Human Head

IDEAS FOR CREATING CHARACTERS USING A THREE-FOURTHS VIEW.

THREE-FOURTHS VIEW

3/4 VIEW

3/4 VIEW

Three-Quarter View

3/4 VIEW

3/4 VIEW

THREE-QUARTER VIEW

I DON'T FEEL GOOD!

Do we have an official Elvis sighting here?

NOW YOUR CHARACTERS ARE REALLY STARTING TO TAKE SHAPE!

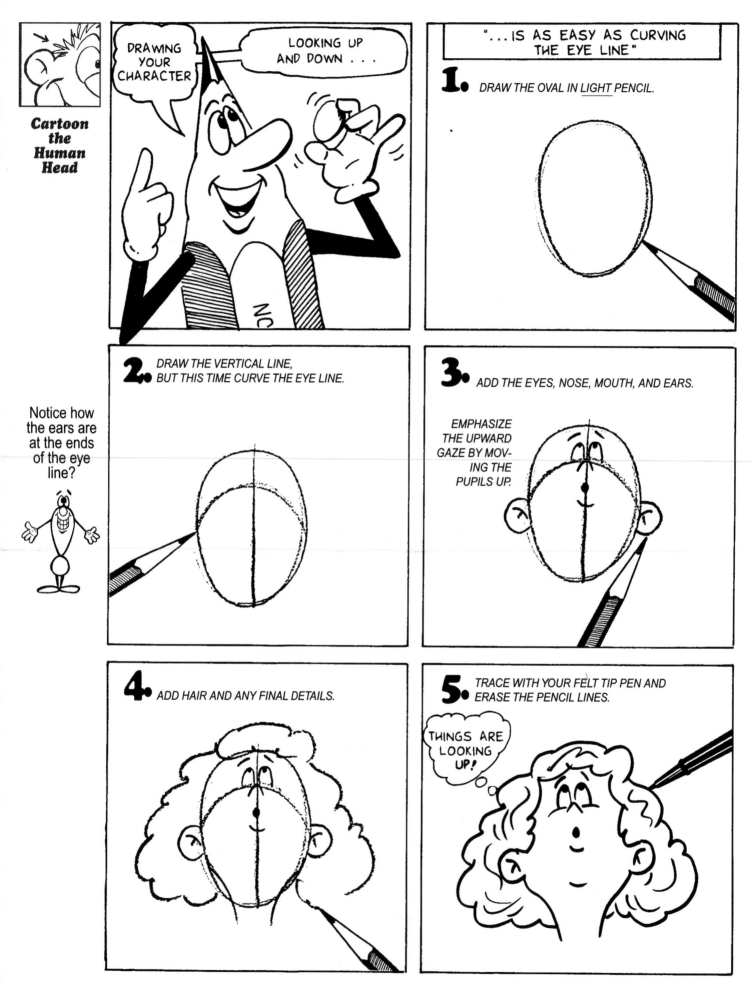

Cartoon the Human Head

Notice how the ears are at the ends of the eye line?

DRAWING YOUR CHARACTER

LOOKING UP AND DOWN . . .

"...IS AS EASY AS CURVING THE EYE LINE"

1. DRAW THE OVAL IN LIGHT PENCIL.

2. DRAW THE VERTICAL LINE, BUT THIS TIME CURVE THE EYE LINE.

3. ADD THE EYES, NOSE, MOUTH, AND EARS.

EMPHASIZE THE UPWARD GAZE BY MOVING THE PUPILS UP.

4. ADD HAIR AND ANY FINAL DETAILS.

5. TRACE WITH YOUR FELT TIP PEN AND ERASE THE PENCIL LINES.

THINGS ARE LOOKING UP!

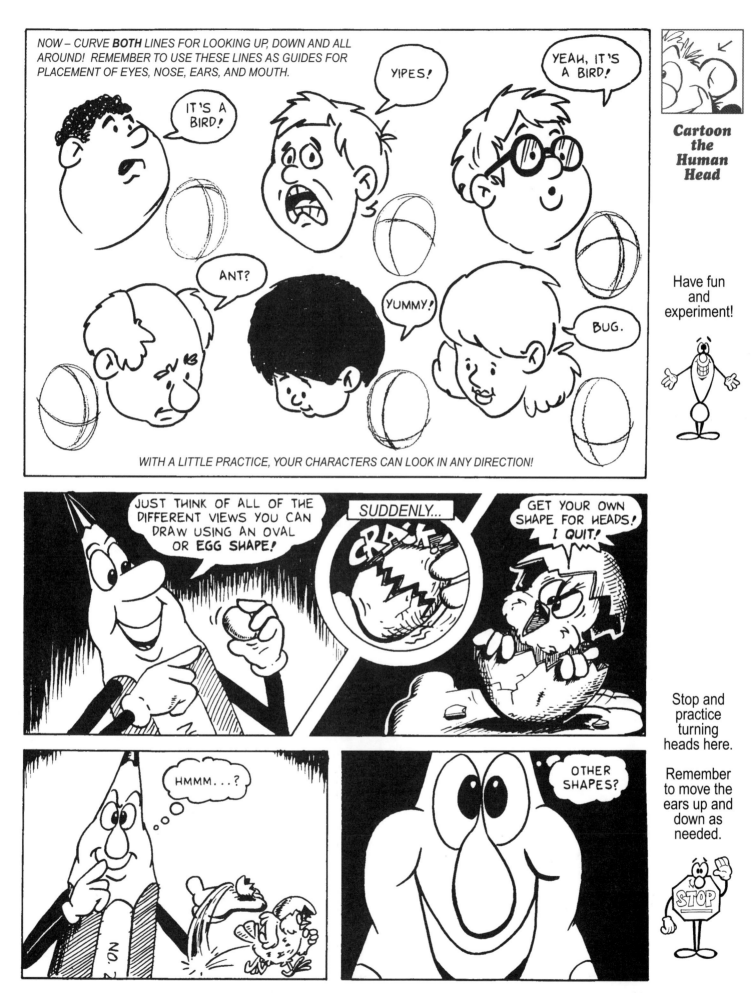

NOW – CURVE **BOTH** LINES FOR LOOKING UP, DOWN AND ALL AROUND! REMEMBER TO USE THESE LINES AS GUIDES FOR PLACEMENT OF EYES, NOSE, EARS, AND MOUTH.

IT'S A BIRD!

YIPES!

YEAH, IT'S A BIRD!

ANT?

YUMMY!

BUG.

WITH A LITTLE PRACTICE, YOUR CHARACTERS CAN LOOK IN ANY DIRECTION!

Cartoon
the
Human
Head

Have fun
and
experiment!

JUST THINK OF ALL OF THE DIFFERENT VIEWS YOU CAN DRAW USING AN OVAL OR EGG SHAPE!

SUDDENLY...

CRACK!

GET YOUR OWN SHAPE FOR HEADS! I QUIT!

HMMM...?

OTHER SHAPES?

NO. 2

Stop and
practice
turning
heads here.

Remember
to move the
ears up and
down as
needed.

STOP

21.

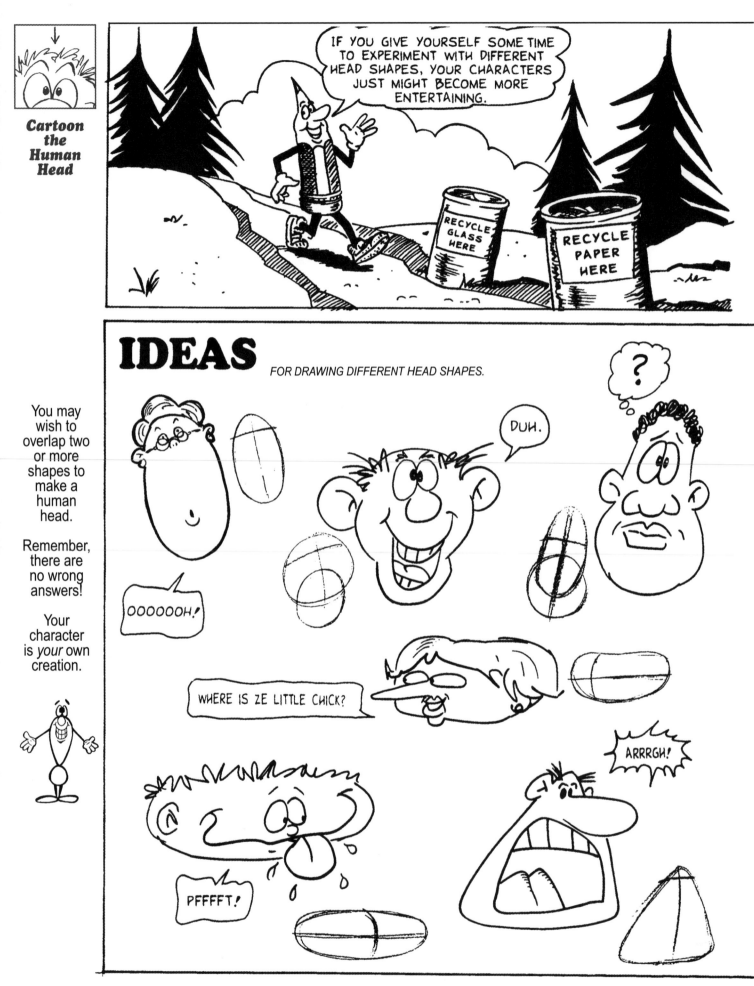

IDEAS

FOR DRAWING DIFFERENT HEAD SHAPES.

You may wish to overlap two or more shapes to make a human head.

Remember, there are no wrong answers!

Your character is *your* own creation.

OOOOOOH!

DUH.

?

WHERE IS ZE LITTLE CHICK?

ARRRGH!

PFFFFT!

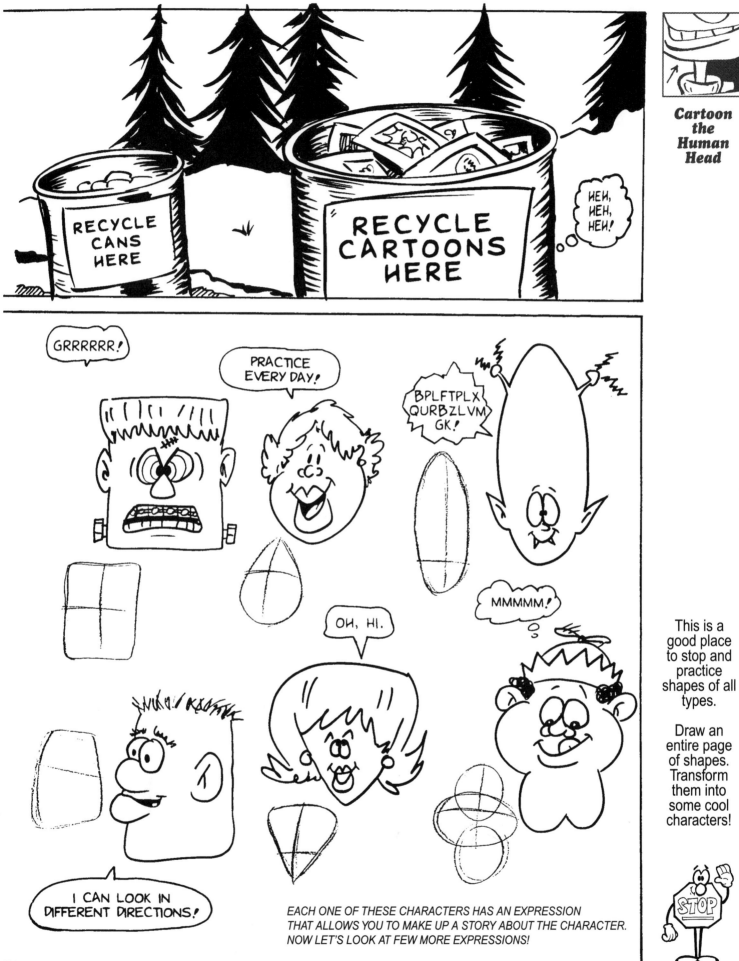

This is a good place to stop and practice shapes of all types.

Draw an entire page of shapes. Transform them into some cool characters!

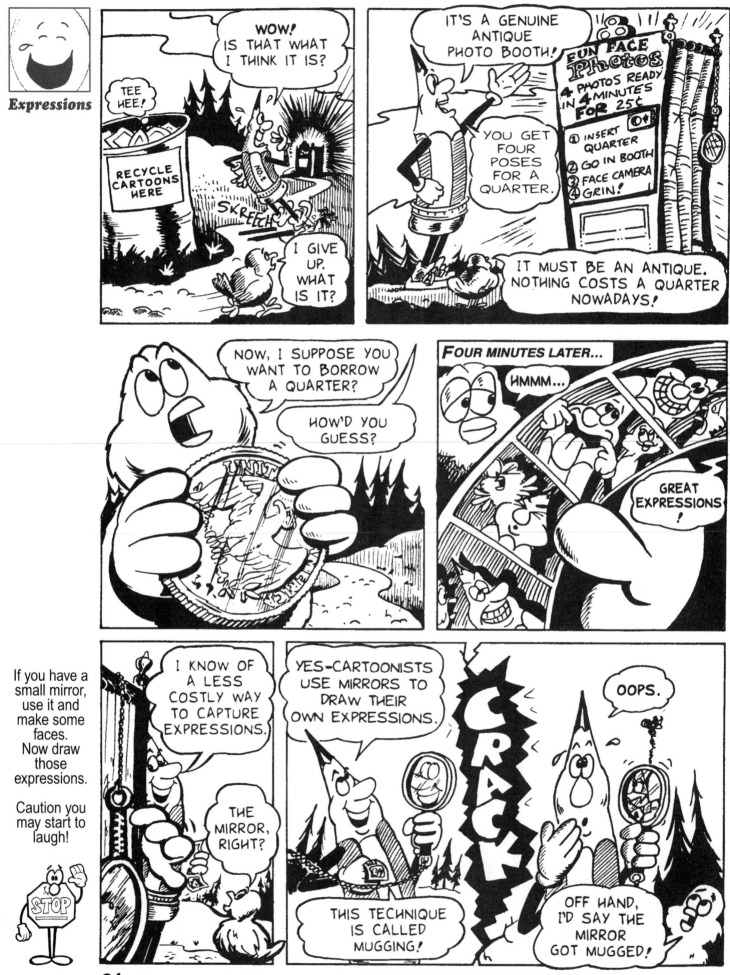

Expressions

If you have a small mirror, use it and make some faces. Now draw those expressions.

Caution you may start to laugh!

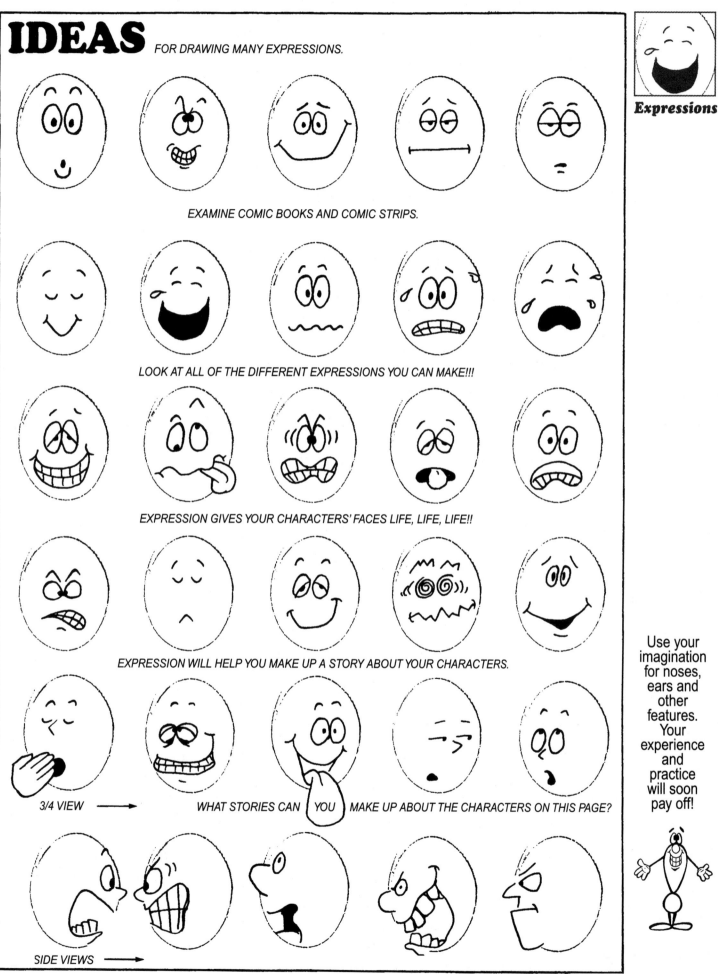

IDEAS

FOR DRAWING MANY EXPRESSIONS.

Expressions

EXAMINE COMIC BOOKS AND COMIC STRIPS.

LOOK AT ALL OF THE DIFFERENT EXPRESSIONS YOU CAN MAKE!!!

EXPRESSION GIVES YOUR CHARACTERS' FACES LIFE, LIFE, LIFE!!

EXPRESSION WILL HELP YOU MAKE UP A STORY ABOUT YOUR CHARACTERS.

3/4 VIEW ➞

WHAT STORIES CAN YOU MAKE UP ABOUT THE CHARACTERS ON THIS PAGE?

SIDE VIEWS ➞

Use your imagination for noses, ears and other features. Your experience and practice will soon pay off!

25.

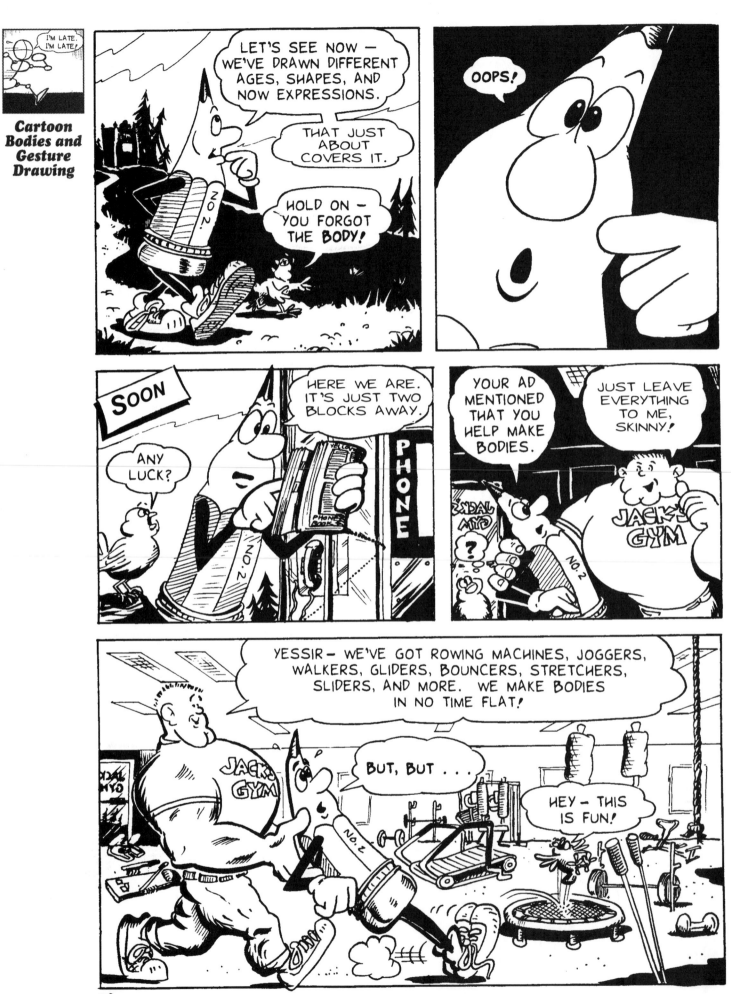

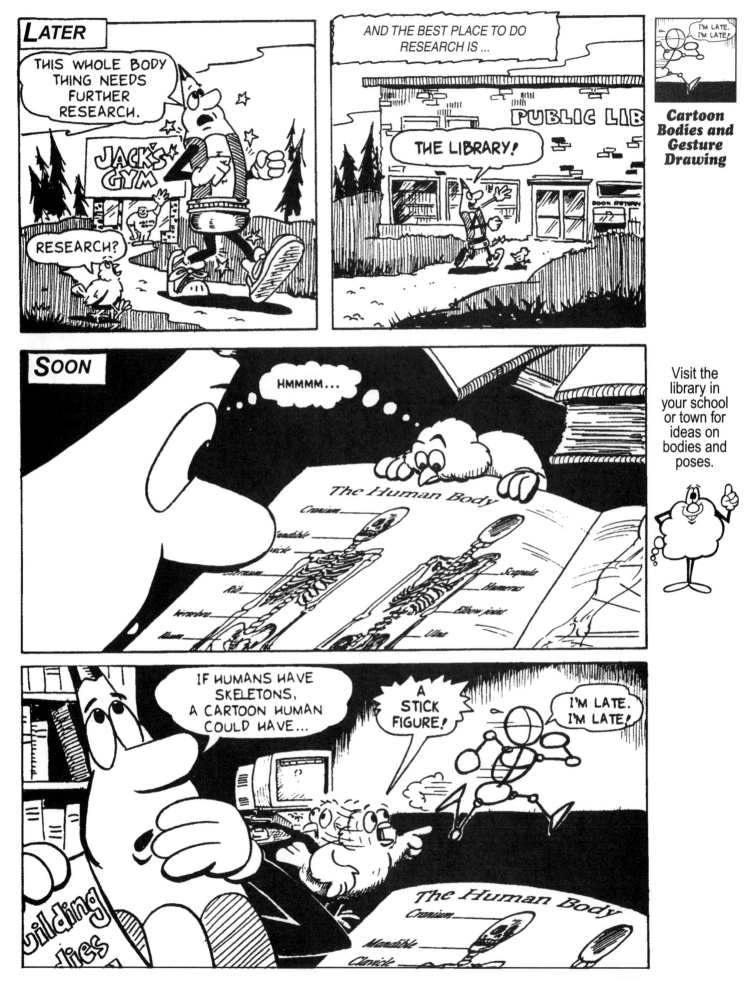

Cartoon Bodies and Gesture Drawing

BODIES & GESTURE DRAWING

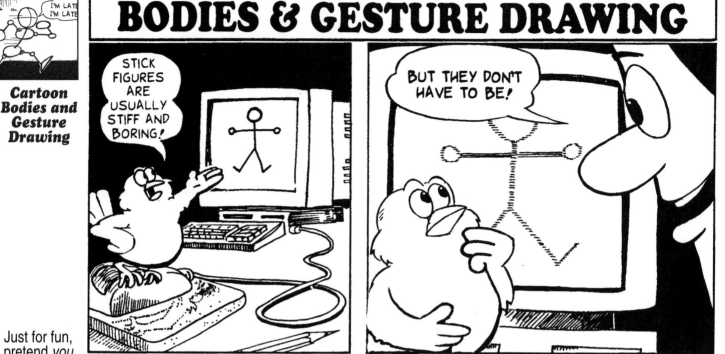

Just for fun, pretend *you* don't have elbows and knees that bend!

THE STICK FIGURE IS VALUABLE TO PROFESSIONAL CARTOONISTS BECAUSE THEY CAN DRAW THE POSE OF THEIR CHARACTER(S) BEFORE ADDING ANY DETAILS. THIS IS CALLED GESTURE DRAWING. SOME STICK FIGURES LOOK STIFF BECAUSE THEY DON'T HAVE **FLEXIBLE BACKBONES** OR **JOINTS**, SO THEIR BODIES CAN'T BEND. (THINK ABOUT HOW YOUR LIFE WOULD CHANGE IF YOU HAD ONE, LONG, SOLID BONE IN YOUR BACK AND YOU DIDN'T HAVE ELBOWS OR KNEES!) FOLLOW THESE SIMPLE STEPS FOR CREATING GESTURE DRAWINGS USING **ACTIVE STICK FIGURES.** YOUR CHARACTERS WILL BE MORE INTERESTING TO LOOK AT, AND HAVE **A LOT MORE FUN!**

Allow enough room on your paper. Steps 3 – 6 will give you an idea of the space you'll need.

1.
DRAW A GENTLY CURVED LINE IN <u>LIGHT</u> PENCIL. THIS IS CALLED THE **ACTION LINE.**

THE **ACTION LINE** GIVES YOUR CHARACTER MOVEMENT AND LIFE SO IT'S NOT STIFF AND BORING.

2.
DRAW A HEAD SHAPE ON THE TOP END OF THE LINE. (AN OVAL IS USED HERE – YOU MAY WANT A DIFFERENT SHAPE.)

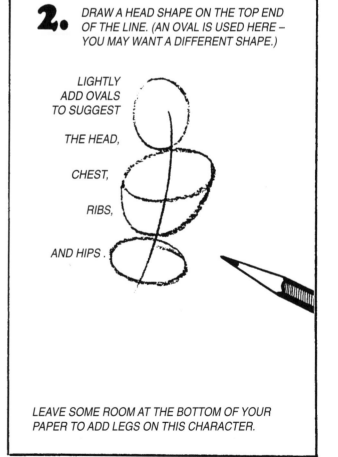

LIGHTLY ADD OVALS TO SUGGEST

THE HEAD,

CHEST,

RIBS,

AND HIPS .

LEAVE SOME ROOM AT THE BOTTOM OF YOUR PAPER TO ADD LEGS ON THIS CHARACTER.

3. ADD THE ARMS, LEGS, HANDS, AND FEET IN <u>LIGHT</u> PENCIL. REMEMBER THAT ARMS AND LEGS HAVE JOINTS.

DRAW A SMALL CIRCLE FOR EACH JOINT.

FOR MORE ABOUT HANDS AND FEET, SEE PAGES 39 – 43.

4. ADD SHAPES LIKE THESE FOR THE MUSCLES, AND GIVE YOUR CHARACTER AN EXPRESSION.

FOR MORE ABOUT ADDING MUSCLES, SEE PAGES 32 – 37.

I'M LATE. I'M LATE!

Cartoon Bodies and Gesture Drawing

Think of the muscles here as paper drink cups. It might help.

5. DRAW THE CLOTHING IN <u>LIGHT</u> PENCIL AND ADD MORE DETAILS.

6. TRACE ONLY THE LINES YOU WANT TO KEEP WITH YOUR PEN, AND ERASE ALL THE PENCIL LINES. ADD A BACKGROUND, TOO!

HERE AT 1475 FT. ABOVE THE OCEAN THE MIGHTY MISSISSIPPI BEGINS TO FLOW ON IT'S WINDING WAY 2552 MILES TO THE GULF OF MEXICO

THE MISSISSIPPI RIVER BEGINS IN MINNESOTA.

TOOM ON

Stop to study how the clothing goes over the body. Keep your pencil lines *light!*

Building bodies takes practice!

STOP

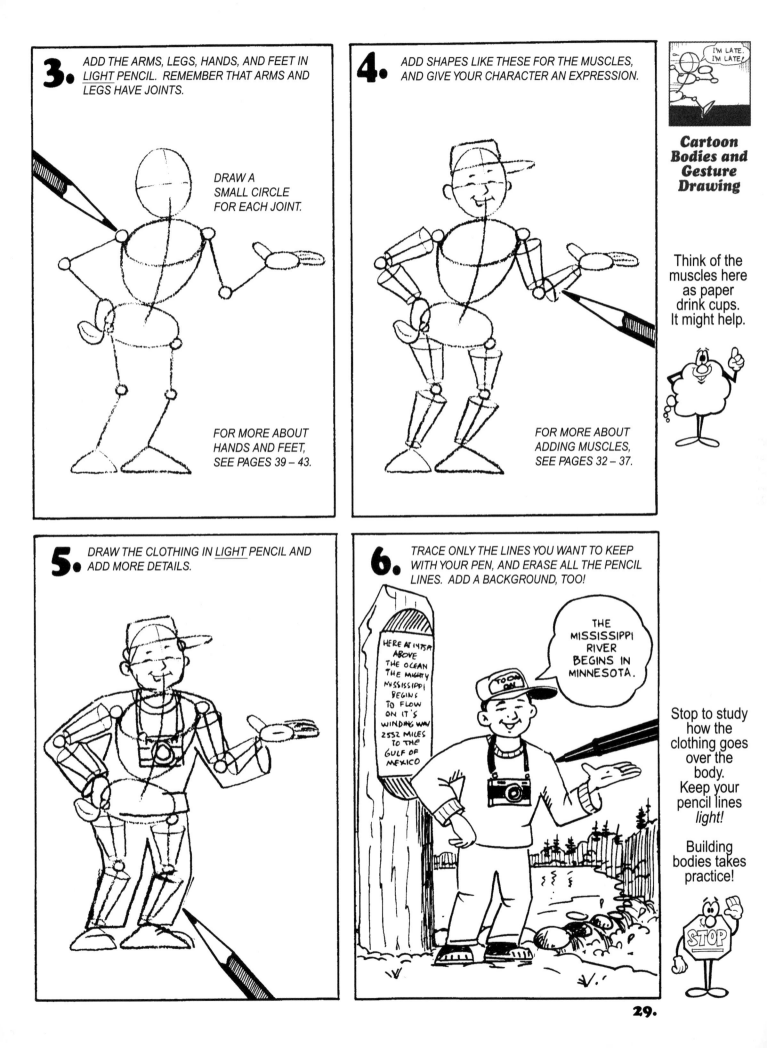

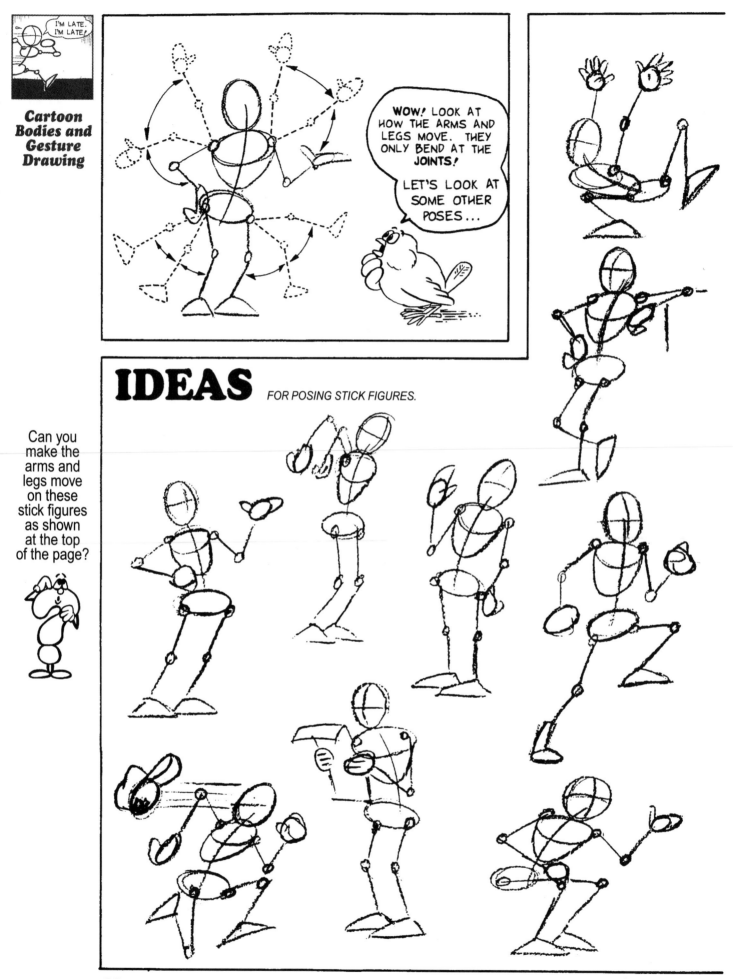

Cartoon Bodies and Gesture Drawing

WOW! LOOK AT HOW THE ARMS AND LEGS MOVE. THEY ONLY BEND AT THE **JOINTS!**

LET'S LOOK AT SOME OTHER POSES...

IDEAS *FOR POSING STICK FIGURES.*

Can you make the arms and legs move on these stick figures as shown at the top of the page?

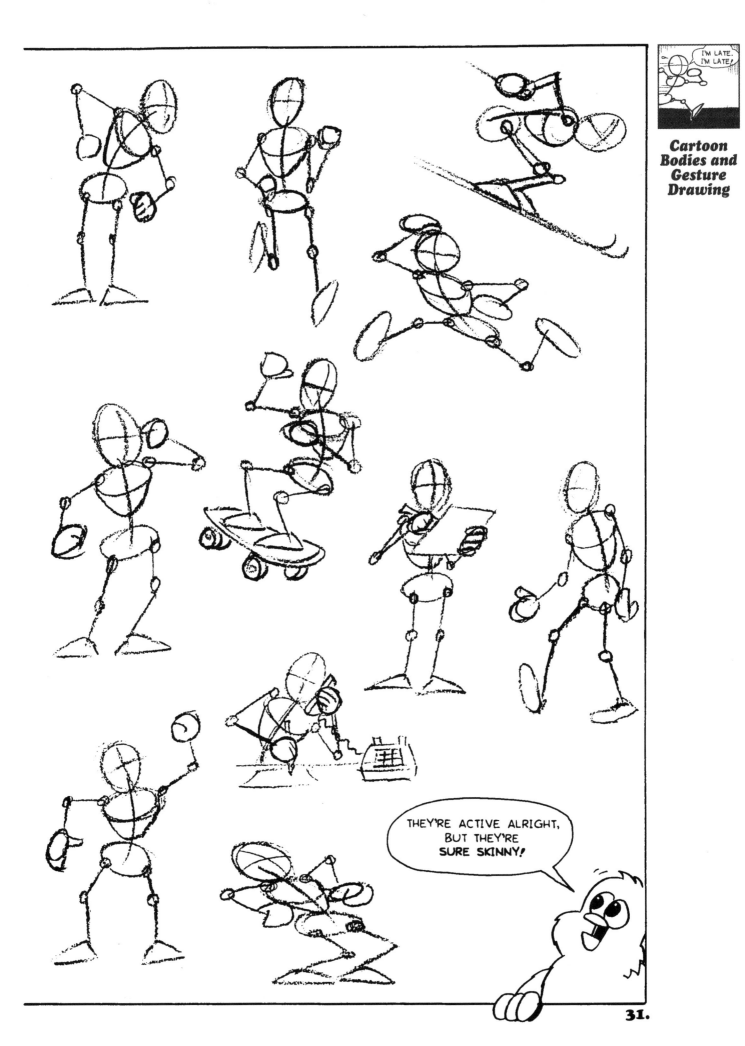

I'M LATE.
I'M LATE!

THEY'RE ACTIVE ALRIGHT,
BUT THEY'RE
SURE SKINNY!

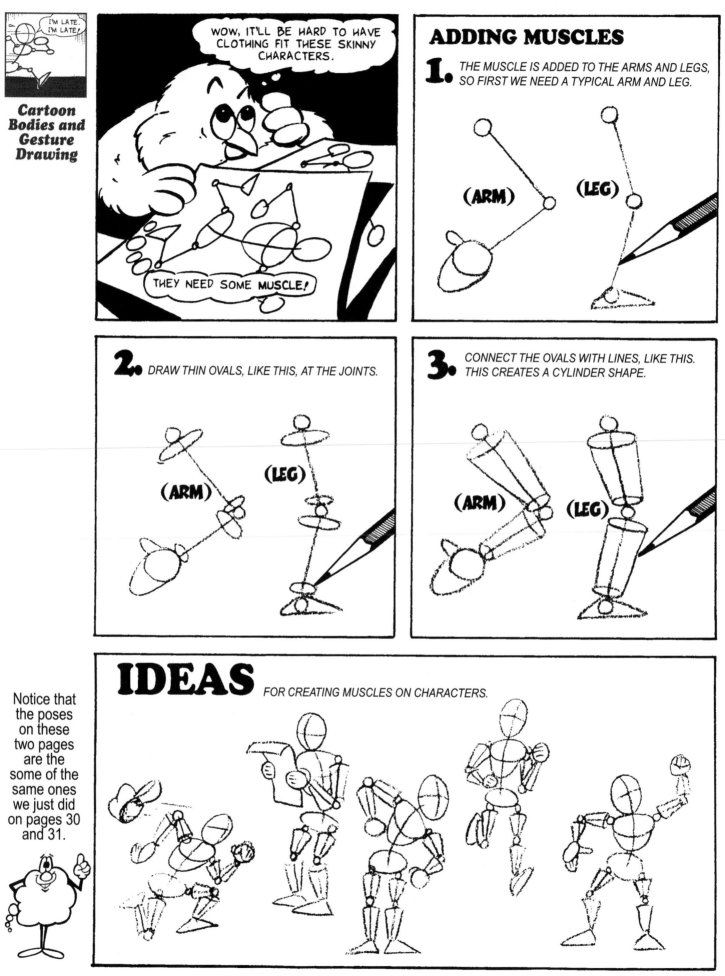

I'M LATE, I'M LATE!

WOW, IT'LL BE HARD TO HAVE CLOTHING FIT THESE SKINNY CHARACTERS.

THEY NEED SOME MUSCLE!

ADDING MUSCLES

1. *THE MUSCLE IS ADDED TO THE ARMS AND LEGS, SO FIRST WE NEED A TYPICAL ARM AND LEG.*

(ARM) (LEG)

2. *DRAW THIN OVALS, LIKE THIS, AT THE JOINTS.*

(ARM) (LEG)

3. *CONNECT THE OVALS WITH LINES, LIKE THIS. THIS CREATES A CYLINDER SHAPE.*

(ARM) (LEG)

IDEAS *FOR CREATING MUSCLES ON CHARACTERS.*

Notice that the poses on these two pages are the some of the same ones we just did on pages 30 and 31.

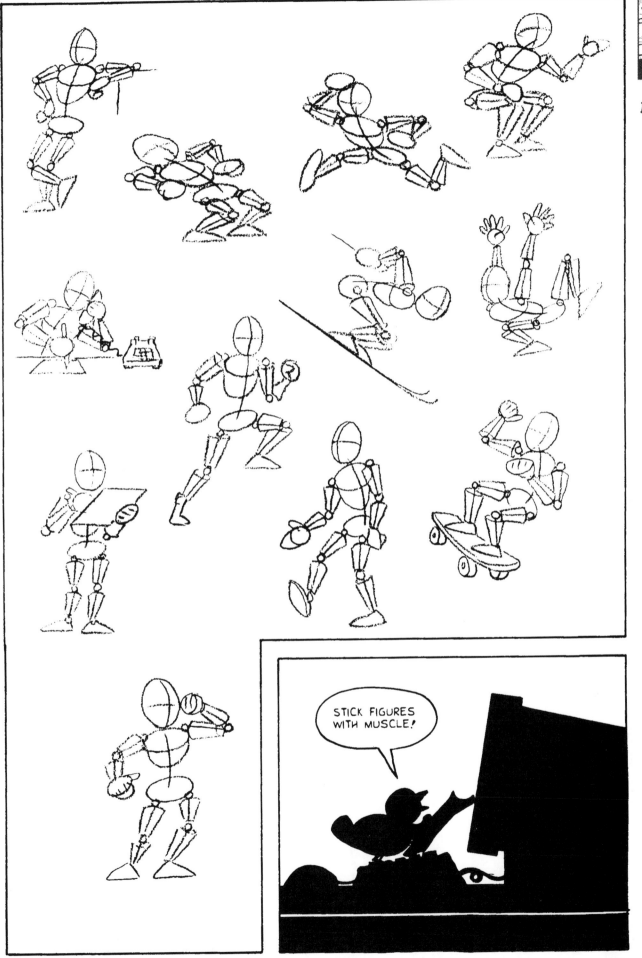

I'M LATE, I'M LATE!

STICK FIGURES WITH MUSCLE!

Poses for these stick figures and muscles take a lot of practice.

Use one or two of the poses and draw them several times until you get the feel of how the muscles work.

STOP

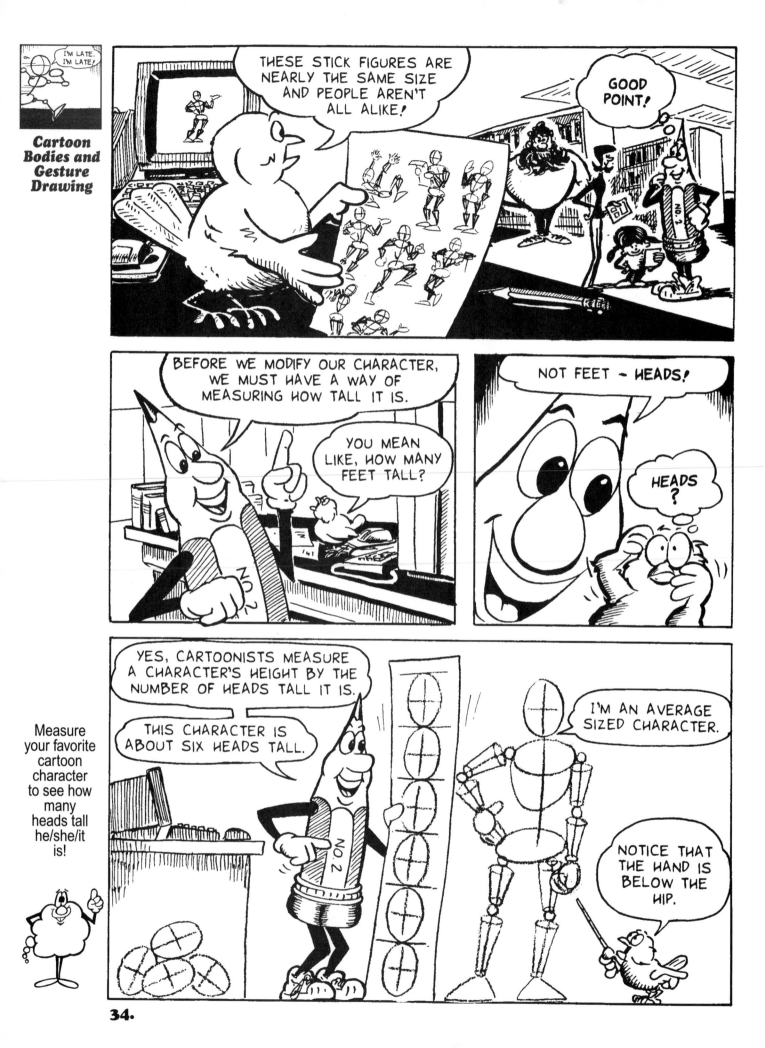

THESE STICK FIGURES ARE NEARLY THE SAME SIZE AND PEOPLE AREN'T ALL ALIKE!

GOOD POINT!

BEFORE WE MODIFY OUR CHARACTER, WE MUST HAVE A WAY OF MEASURING HOW TALL IT IS.

YOU MEAN LIKE, HOW MANY FEET TALL?

NOT FEET - HEADS!

HEADS?

YES, CARTOONISTS MEASURE A CHARACTER'S HEIGHT BY THE NUMBER OF HEADS TALL IT IS.

THIS CHARACTER IS ABOUT SIX HEADS TALL.

I'M AN AVERAGE SIZED CHARACTER.

NOTICE THAT THE HAND IS BELOW THE HIP.

Measure your favorite cartoon character to see how many heads tall he/she/it is!

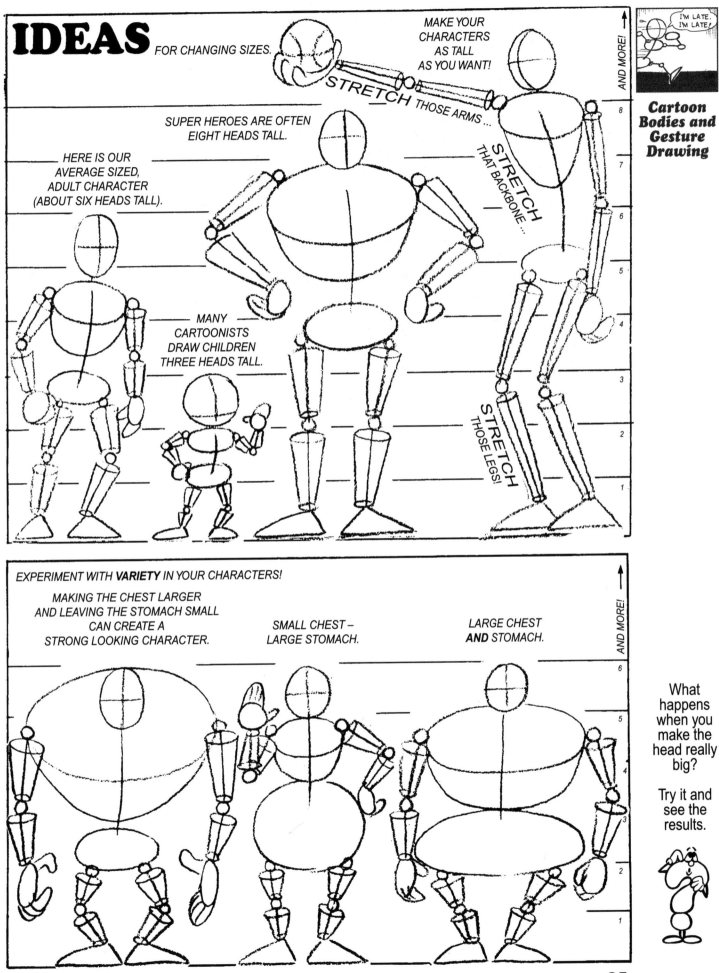

IDEAS FOR CHANGING SIZES.

MAKE YOUR CHARACTERS AS TALL AS YOU WANT!

STRETCH THOSE ARMS...

STRETCH THAT BACKBONE...

STRETCH THOSE LEGS!

SUPER HEROES ARE OFTEN EIGHT HEADS TALL.

HERE IS OUR AVERAGE SIZED, ADULT CHARACTER (ABOUT SIX HEADS TALL).

MANY CARTOONISTS DRAW CHILDREN THREE HEADS TALL.

AND MORE!

I'M LATE. I'M LATE!

EXPERIMENT WITH **VARIETY** IN YOUR CHARACTERS!

MAKING THE CHEST LARGER AND LEAVING THE STOMACH SMALL CAN CREATE A STRONG LOOKING CHARACTER.

SMALL CHEST – LARGE STOMACH.

LARGE CHEST **AND** STOMACH.

AND MORE!

What happens when you make the head really big?

Try it and see the results.

35.

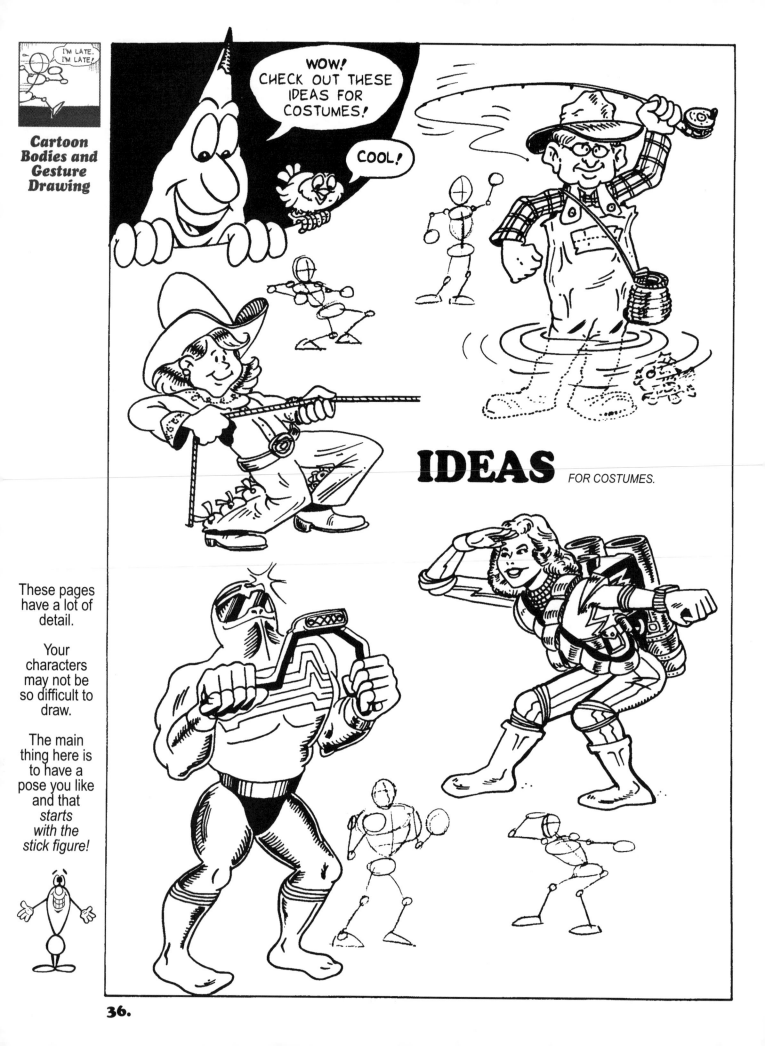

WOW! CHECK OUT THESE IDEAS FOR COSTUMES!

COOL!

IDEAS FOR COSTUMES.

These pages have a lot of detail.

Your characters may not be so difficult to draw.

The main thing here is to have a pose you like and that *starts with the stick figure!*

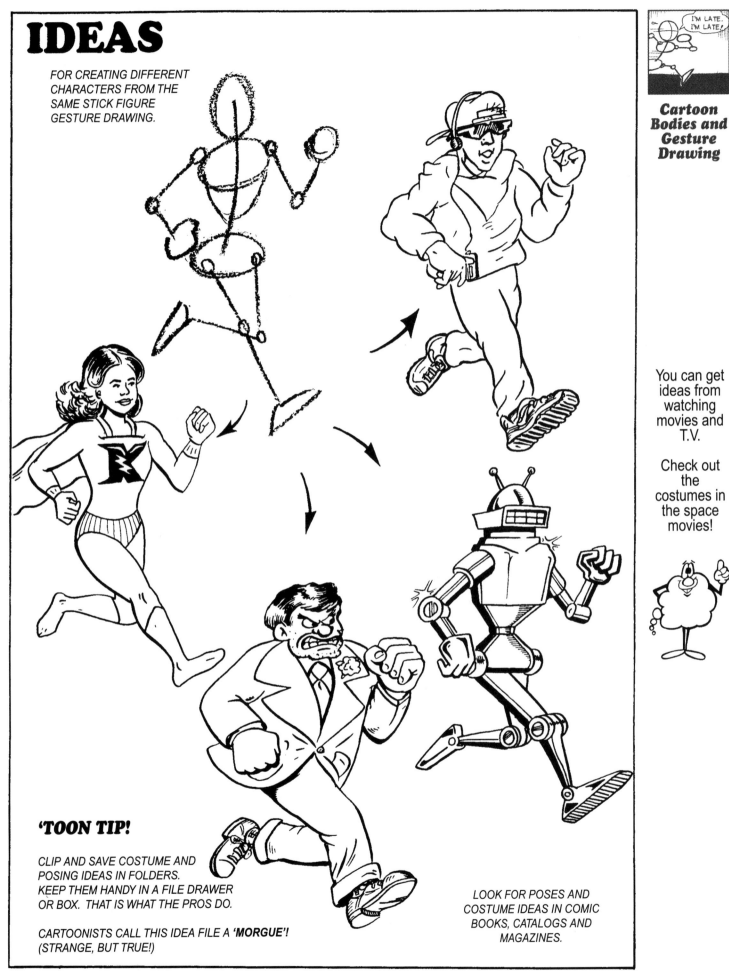

IDEAS

FOR CREATING DIFFERENT
CHARACTERS FROM THE
SAME STICK FIGURE
GESTURE DRAWING.

I'M LATE.
I'M LATE.

You can get
ideas from
watching
movies and
T.V.

Check out
the
costumes in
the space
movies!

'TOON TIP!

CLIP AND SAVE COSTUME AND
POSING IDEAS IN FOLDERS.
KEEP THEM HANDY IN A FILE DRAWER
OR BOX. THAT IS WHAT THE PROS DO.

CARTOONISTS CALL THIS IDEA FILE A **'MORGUE'**!
(STRANGE, BUT TRUE!)

LOOK FOR POSES AND
COSTUME IDEAS IN COMIC
BOOKS, CATALOGS AND
MAGAZINES.

DRAWING HANDS

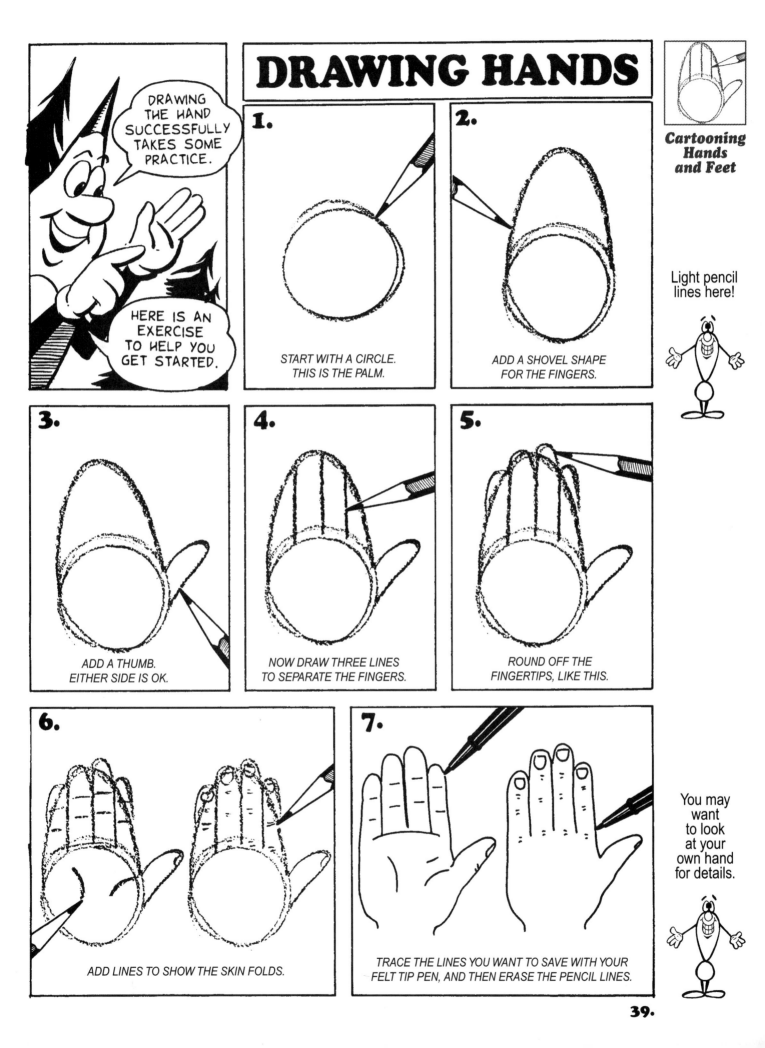

DRAWING THE HAND SUCCESSFULLY TAKES SOME PRACTICE.

HERE IS AN EXERCISE TO HELP YOU GET STARTED.

Cartooning Hands and Feet

Light pencil lines here!

1. START WITH A CIRCLE. THIS IS THE PALM.

2. ADD A SHOVEL SHAPE FOR THE FINGERS.

3. ADD A THUMB. EITHER SIDE IS OK.

4. NOW DRAW THREE LINES TO SEPARATE THE FINGERS.

5. ROUND OFF THE FINGERTIPS, LIKE THIS.

6. ADD LINES TO SHOW THE SKIN FOLDS.

7. TRACE THE LINES YOU WANT TO SAVE WITH YOUR FELT TIP PEN, AND THEN ERASE THE PENCIL LINES.

You may want to look at your own hand for details.

39.

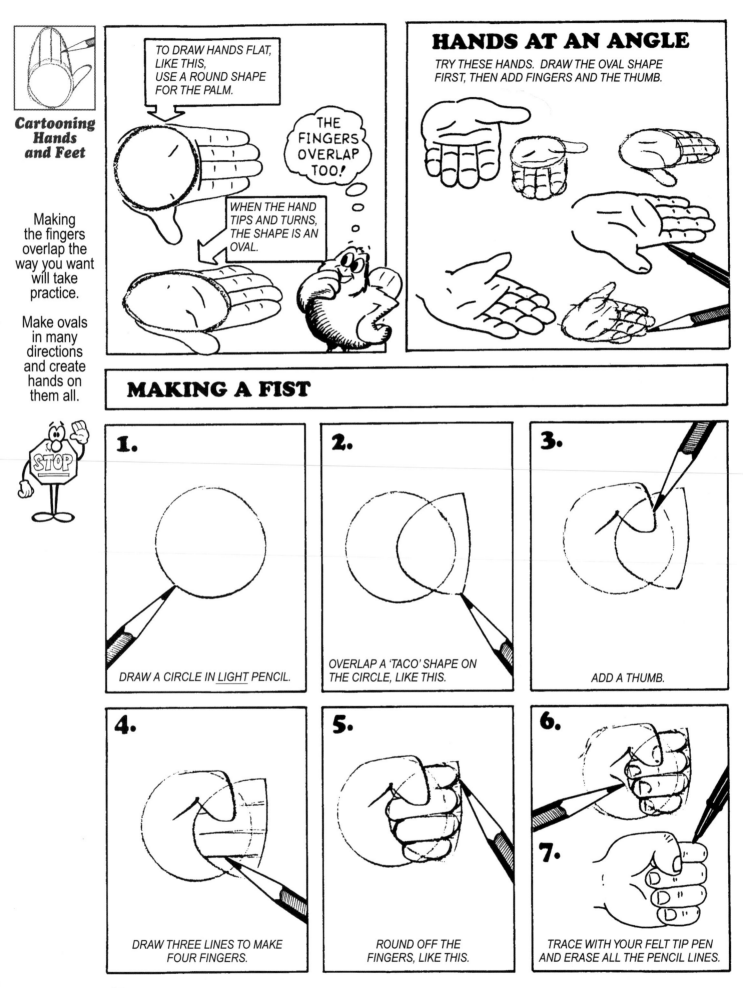

Cartooning Hands and Feet

Making the fingers overlap the way you want will take practice.

Make ovals in many directions and create hands on them all.

TO DRAW HANDS FLAT, LIKE THIS, USE A ROUND SHAPE FOR THE PALM.

THE FINGERS OVERLAP TOO!

WHEN THE HAND TIPS AND TURNS, THE SHAPE IS AN OVAL.

HANDS AT AN ANGLE

TRY THESE HANDS. DRAW THE OVAL SHAPE FIRST, THEN ADD FINGERS AND THE THUMB.

MAKING A FIST

1. DRAW A CIRCLE IN <u>LIGHT</u> PENCIL.

2. OVERLAP A 'TACO' SHAPE ON THE CIRCLE, LIKE THIS.

3. ADD A THUMB.

4. DRAW THREE LINES TO MAKE FOUR FINGERS.

5. ROUND OFF THE FINGERS, LIKE THIS.

6.

7. TRACE WITH YOUR FELT TIP PEN AND ERASE ALL THE PENCIL LINES.

IDEAS

FOR HAND POSITIONS.

Cartooning Hands and Feet

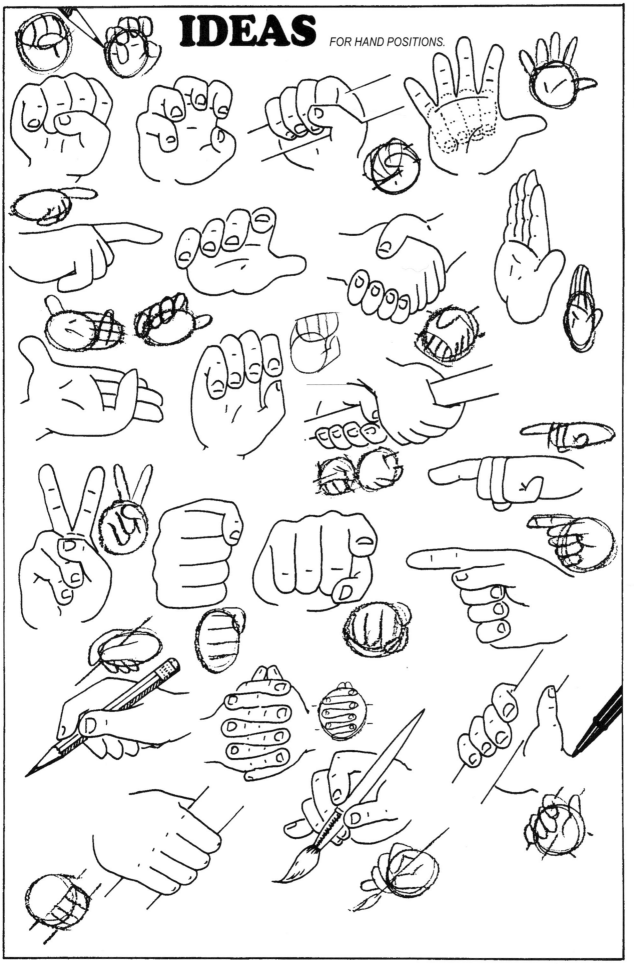

By holding this page up to a mirror, you can see what the opposite hand looks like.

Use this technique when you need another hand.

41.

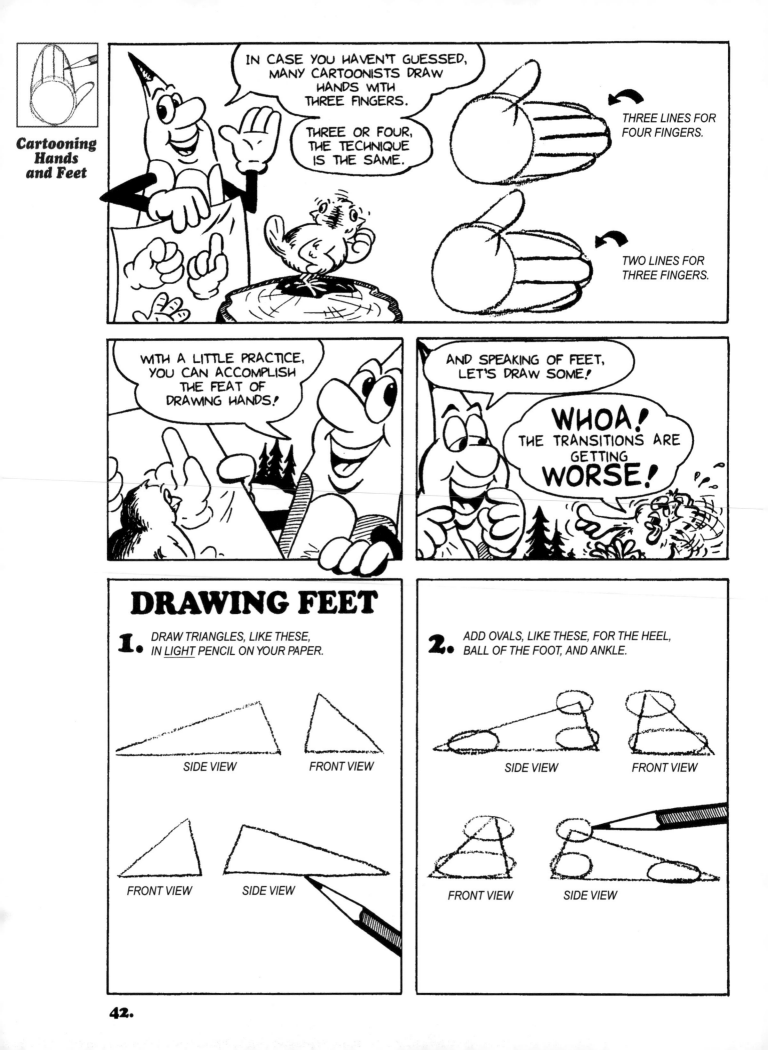

Cartooning Hands and Feet

IN CASE YOU HAVEN'T GUESSED, MANY CARTOONISTS DRAW HANDS WITH THREE FINGERS.

THREE OR FOUR, THE TECHNIQUE IS THE SAME.

THREE LINES FOR FOUR FINGERS.

TWO LINES FOR THREE FINGERS.

WITH A LITTLE PRACTICE, YOU CAN ACCOMPLISH THE FEAT OF DRAWING HANDS!

AND SPEAKING OF FEET, LET'S DRAW SOME!

WHOA! THE TRANSITIONS ARE GETTING WORSE!

DRAWING FEET

1. DRAW TRIANGLES, LIKE THESE, IN <u>LIGHT</u> PENCIL ON YOUR PAPER.

SIDE VIEW FRONT VIEW

FRONT VIEW SIDE VIEW

2. ADD OVALS, LIKE THESE, FOR THE HEEL, BALL OF THE FOOT, AND ANKLE.

SIDE VIEW FRONT VIEW

FRONT VIEW SIDE VIEW

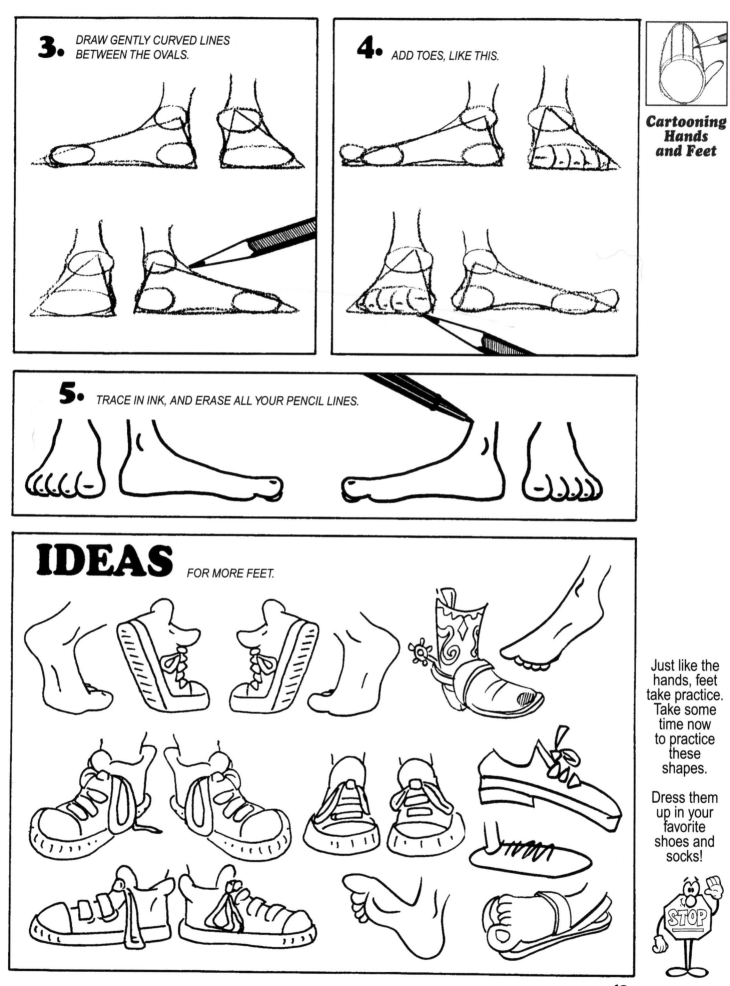

3. DRAW GENTLY CURVED LINES BETWEEN THE OVALS.

4. ADD TOES, LIKE THIS.

Cartooning Hands and Feet

5. TRACE IN INK, AND ERASE ALL YOUR PENCIL LINES.

IDEAS FOR MORE FEET.

Just like the hands, feet take practice. Take some time now to practice these shapes.

Dress them up in your favorite shoes and socks!

STOP

43.

Cartoons on greeting cards make great gifts, too!

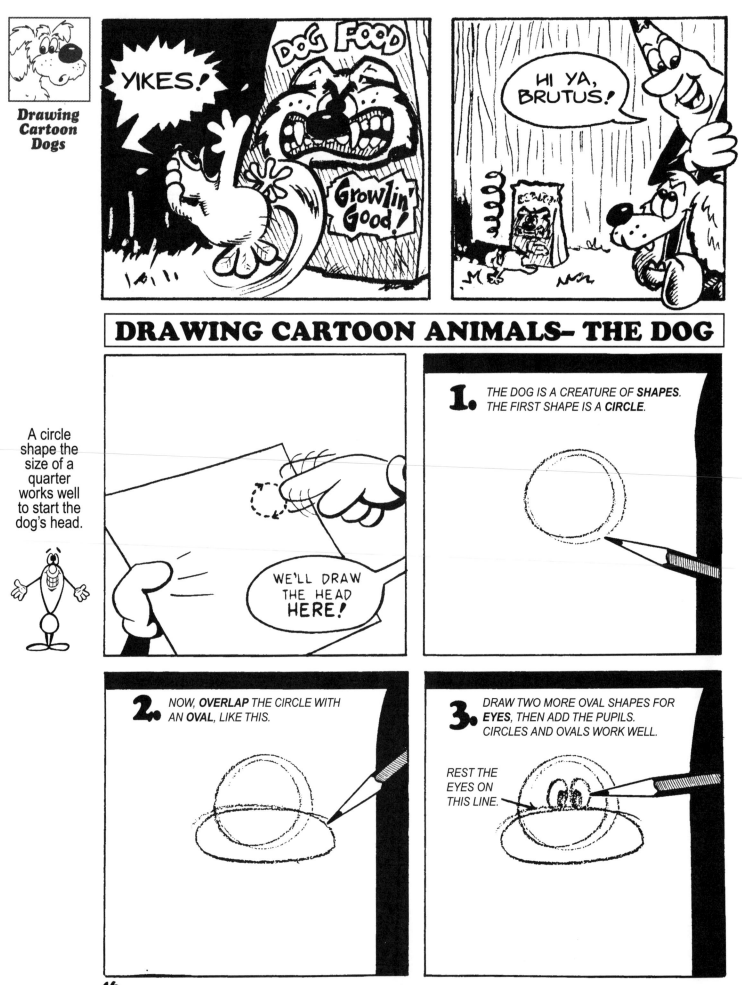

Drawing Cartoon Dogs

YIKES!

DOG FOOD

Growlin' Good!

HI YA, BRUTUS!

DRAWING CARTOON ANIMALS– THE DOG

A circle shape the size of a quarter works well to start the dog's head.

WE'LL DRAW THE HEAD **HERE!**

1. *THE DOG IS A CREATURE OF **SHAPES**. THE FIRST SHAPE IS A **CIRCLE**.*

2. *NOW, **OVERLAP** THE CIRCLE WITH AN **OVAL**, LIKE THIS.*

3. *DRAW TWO MORE OVAL SHAPES FOR **EYES**, THEN ADD THE PUPILS. CIRCLES AND OVALS WORK WELL.*

REST THE EYES ON THIS LINE.

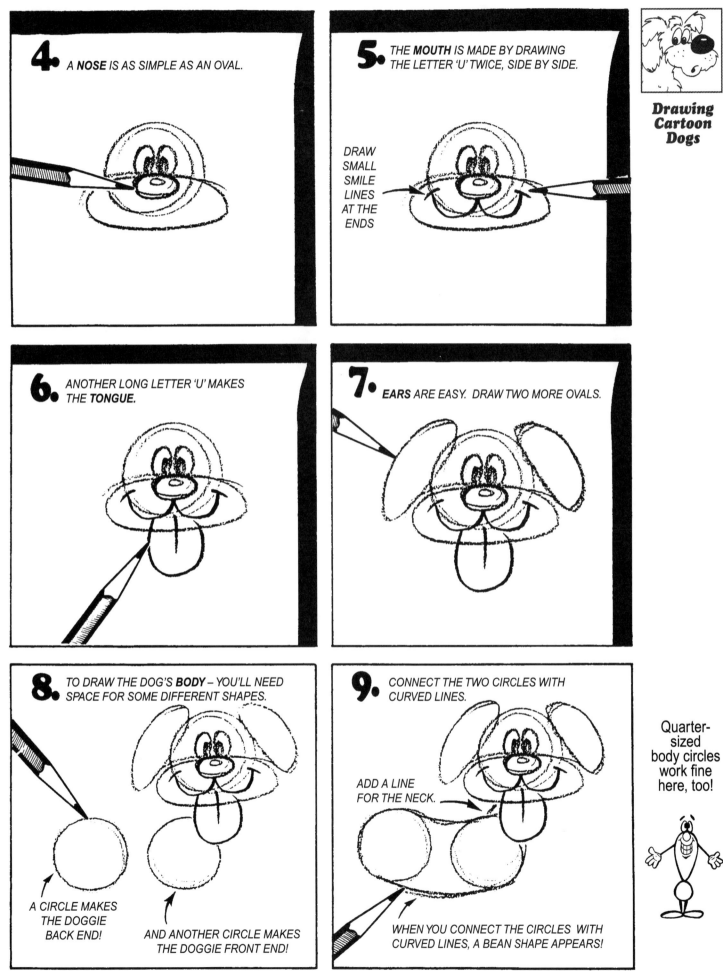

4. A **NOSE** IS AS SIMPLE AS AN OVAL.

5. THE **MOUTH** IS MADE BY DRAWING THE LETTER 'U' TWICE, SIDE BY SIDE.

DRAW SMALL SMILE LINES AT THE ENDS

Drawing Cartoon Dogs

6. ANOTHER LONG LETTER 'U' MAKES THE **TONGUE**.

7. **EARS** ARE EASY. DRAW TWO MORE OVALS.

8. TO DRAW THE DOG'S **BODY** – YOU'LL NEED SPACE FOR SOME DIFFERENT SHAPES.

A CIRCLE MAKES THE DOGGIE BACK END!

AND ANOTHER CIRCLE MAKES THE DOGGIE FRONT END!

9. CONNECT THE TWO CIRCLES WITH CURVED LINES.

ADD A LINE FOR THE NECK.

WHEN YOU CONNECT THE CIRCLES WITH CURVED LINES, A BEAN SHAPE APPEARS!

Quarter-sized body circles work fine here, too!

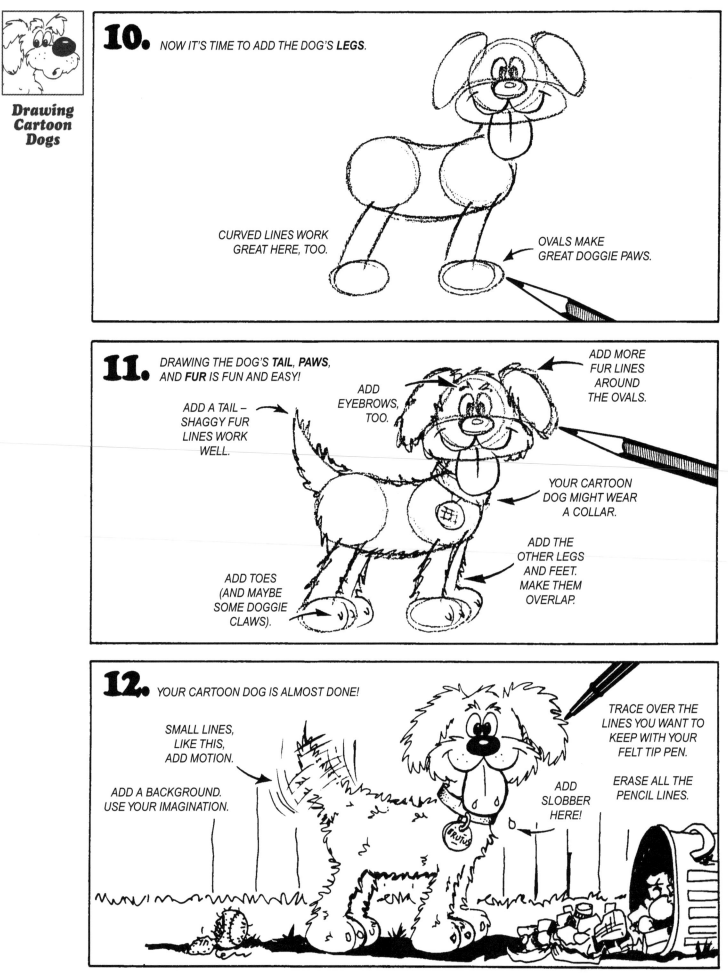

Drawing Cartoon Dogs

10. NOW IT'S TIME TO ADD THE DOG'S **LEGS**.

CURVED LINES WORK GREAT HERE, TOO.

OVALS MAKE GREAT DOGGIE PAWS.

11. DRAWING THE DOG'S **TAIL**, **PAWS**, AND **FUR** IS FUN AND EASY!

ADD A TAIL – SHAGGY FUR LINES WORK WELL.

ADD EYEBROWS, TOO.

ADD MORE FUR LINES AROUND THE OVALS.

YOUR CARTOON DOG MIGHT WEAR A COLLAR.

ADD THE OTHER LEGS AND FEET. MAKE THEM OVERLAP.

ADD TOES (AND MAYBE SOME DOGGIE CLAWS).

12. YOUR CARTOON DOG IS ALMOST DONE!

SMALL LINES, LIKE THIS, ADD MOTION.

ADD A BACKGROUND. USE YOUR IMAGINATION.

TRACE OVER THE LINES YOU WANT TO KEEP WITH YOUR FELT TIP PEN.

ERASE ALL THE PENCIL LINES.

ADD SLOBBER HERE!

48.

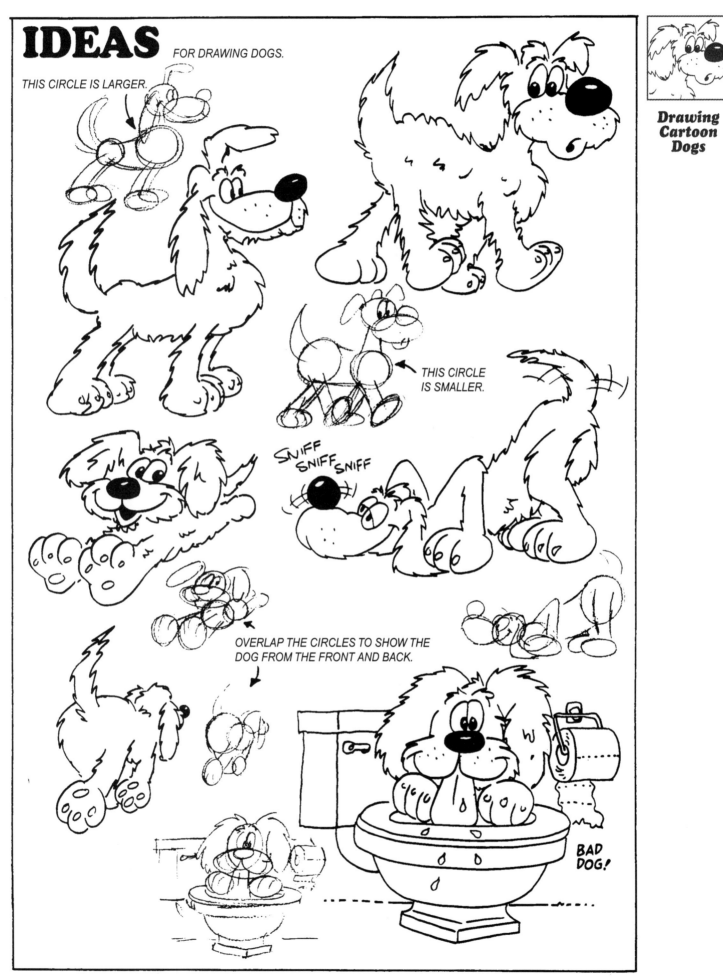

IDEAS

FOR DRAWING DOGS.

THIS CIRCLE IS LARGER.

THIS CIRCLE IS SMALLER.

SNIFF SNIFF SNIFF

OVERLAP THE CIRCLES TO SHOW THE DOG FROM THE FRONT AND BACK.

BAD DOG!

Drawing Cartoon Dogs

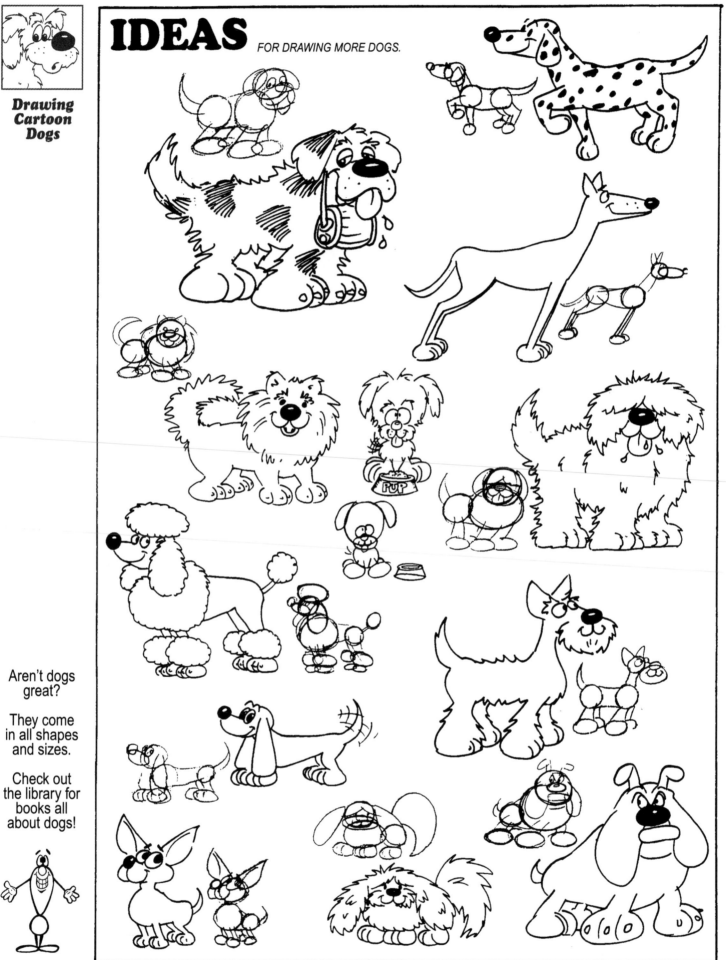

IDEAS

FOR DRAWING MORE DOGS.

Aren't dogs
great?

They come
in all shapes
and sizes.

Check out
the library for
books all
about dogs!

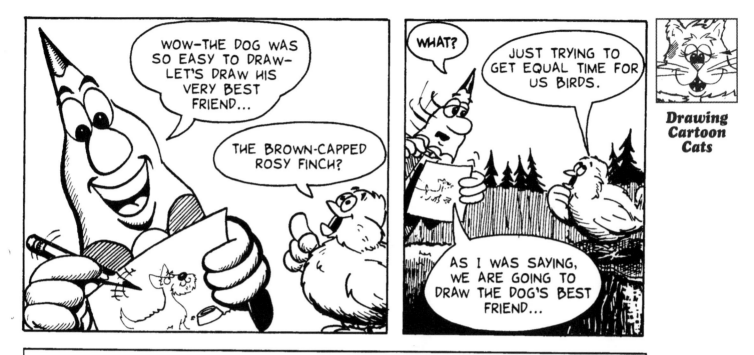

DRAWING CARTOON ANIMALS-THE CAT

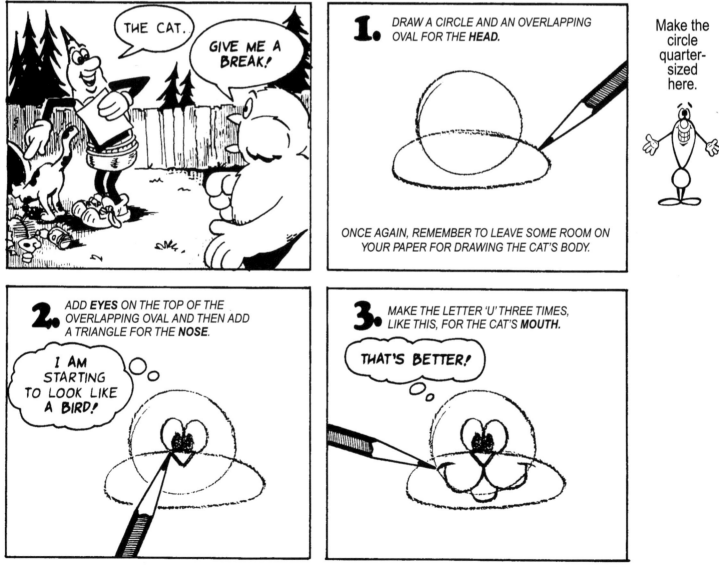

1. DRAW A CIRCLE AND AN OVERLAPPING OVAL FOR THE **HEAD**.

ONCE AGAIN, REMEMBER TO LEAVE SOME ROOM ON YOUR PAPER FOR DRAWING THE CAT'S BODY.

Make the circle quarter-sized here.

2. ADD **EYES** ON THE TOP OF THE OVERLAPPING OVAL AND THEN ADD A TRIANGLE FOR THE **NOSE**.

3. MAKE THE LETTER 'U' THREE TIMES, LIKE THIS, FOR THE CAT'S **MOUTH**.

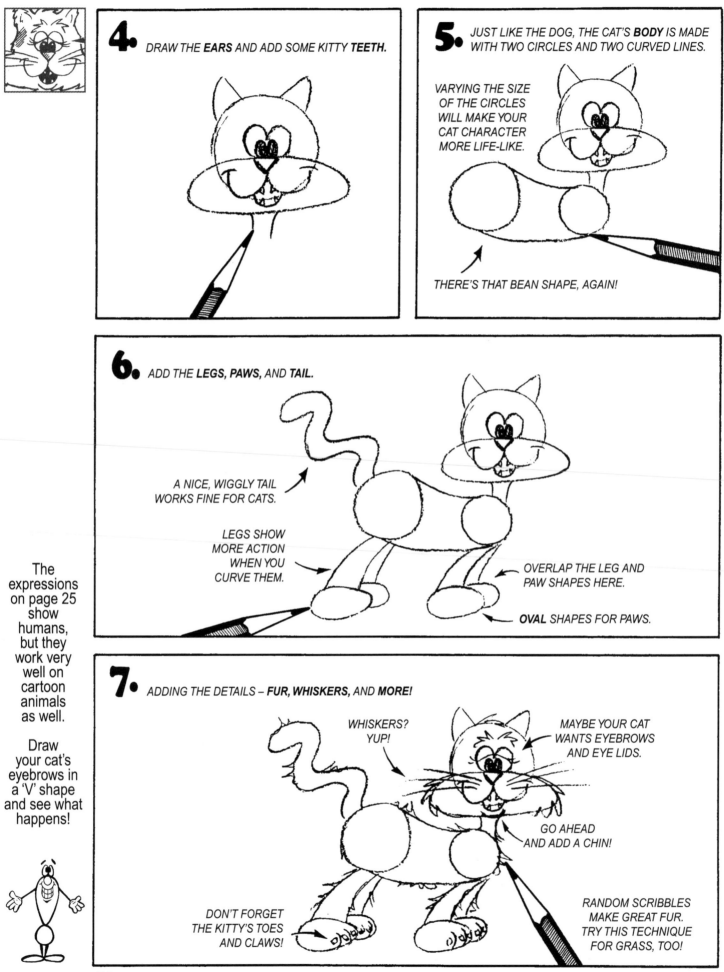

4. DRAW THE **EARS** AND ADD SOME KITTY **TEETH**.

5. JUST LIKE THE DOG, THE CAT'S **BODY** IS MADE WITH TWO CIRCLES AND TWO CURVED LINES.

VARYING THE SIZE OF THE CIRCLES WILL MAKE YOUR CAT CHARACTER MORE LIFE-LIKE.

THERE'S THAT BEAN SHAPE, AGAIN!

6. ADD THE **LEGS**, **PAWS**, AND **TAIL**.

A NICE, WIGGLY TAIL WORKS FINE FOR CATS.

LEGS SHOW MORE ACTION WHEN YOU CURVE THEM.

OVERLAP THE LEG AND PAW SHAPES HERE.

OVAL SHAPES FOR PAWS.

The expressions on page 25 show humans, but they work very well on cartoon animals as well.

Draw your cat's eyebrows in a 'V' shape and see what happens!

7. ADDING THE DETAILS – **FUR, WHISKERS,** AND **MORE!**

WHISKERS? YUP!

MAYBE YOUR CAT WANTS EYEBROWS AND EYE LIDS.

GO AHEAD AND ADD A CHIN!

DON'T FORGET THE KITTY'S TOES AND CLAWS!

RANDOM SCRIBBLES MAKE GREAT FUR. TRY THIS TECHNIQUE FOR GRASS, TOO!

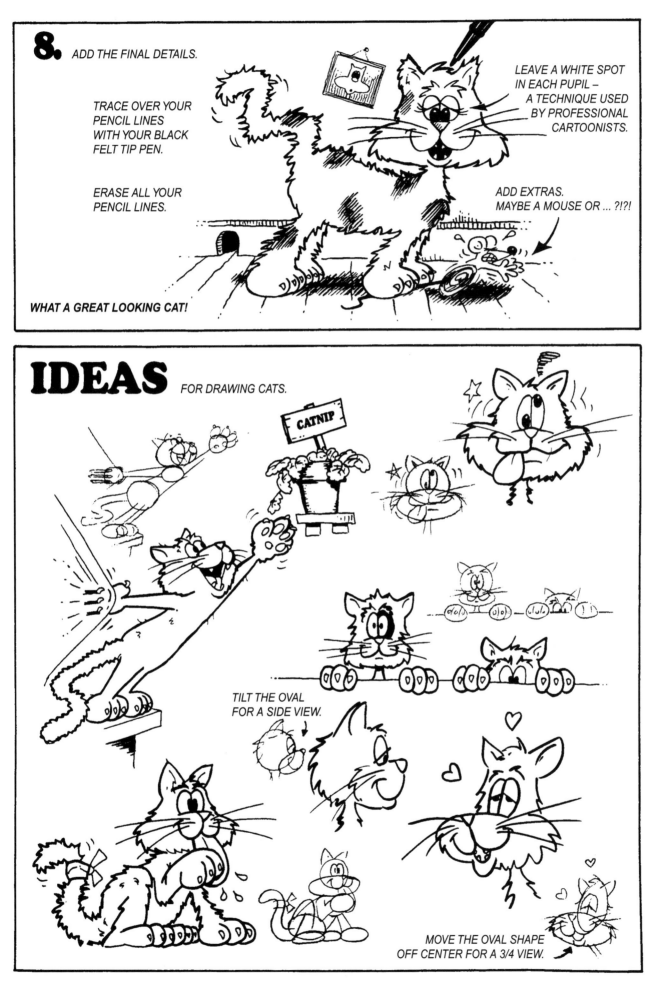

8. *ADD THE FINAL DETAILS.*

TRACE OVER YOUR PENCIL LINES WITH YOUR BLACK FELT TIP PEN.

ERASE ALL YOUR PENCIL LINES.

LEAVE A WHITE SPOT IN EACH PUPIL – A TECHNIQUE USED BY PROFESSIONAL CARTOONISTS.

ADD EXTRAS. MAYBE A MOUSE OR ... ?!?!

WHAT A GREAT LOOKING CAT!

IDEAS *FOR DRAWING CATS.*

CATNIP

TILT THE OVAL FOR A SIDE VIEW.

MOVE THE OVAL SHAPE OFF CENTER FOR A 3/4 VIEW.

IDEAS

FOR DRAWING MORE CATS.

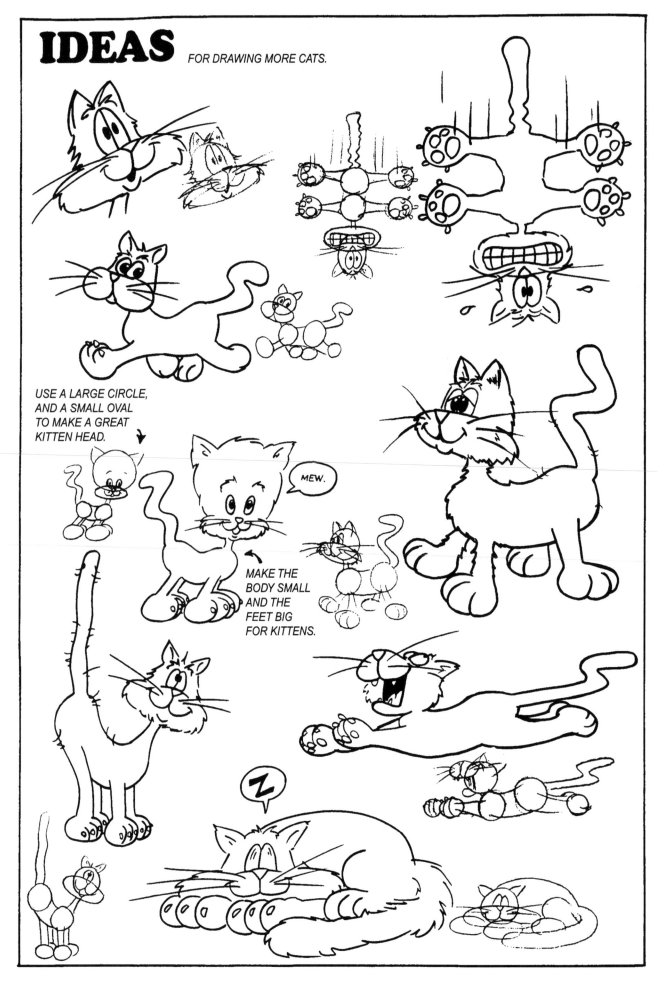

USE A LARGE CIRCLE, AND A SMALL OVAL TO MAKE A GREAT KITTEN HEAD.

MEW.

MAKE THE BODY SMALL AND THE FEET BIG FOR KITTENS.

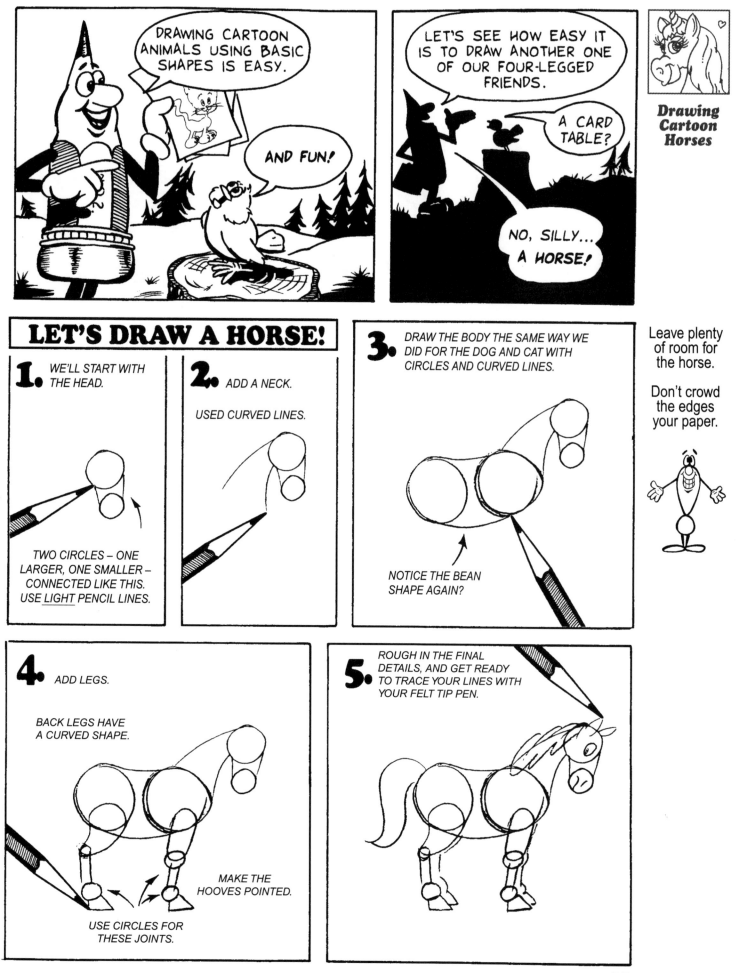

DRAWING CARTOON ANIMALS USING BASIC SHAPES IS EASY.

AND FUN!

LET'S SEE HOW EASY IT IS TO DRAW ANOTHER ONE OF OUR FOUR-LEGGED FRIENDS.

A CARD TABLE?

NO, SILLY... A HORSE!

Drawing Cartoon Horses

LET'S DRAW A HORSE!

1. WE'LL START WITH THE HEAD.

TWO CIRCLES – ONE LARGER, ONE SMALLER – CONNECTED LIKE THIS. USE <u>LIGHT</u> PENCIL LINES.

2. ADD A NECK.

USED CURVED LINES.

3. DRAW THE BODY THE SAME WAY WE DID FOR THE DOG AND CAT WITH CIRCLES AND CURVED LINES.

NOTICE THE BEAN SHAPE AGAIN?

Leave plenty of room for the horse.

Don't crowd the edges your paper.

4. ADD LEGS.

BACK LEGS HAVE A CURVED SHAPE.

MAKE THE HOOVES POINTED.

USE CIRCLES FOR THESE JOINTS.

5. ROUGH IN THE FINAL DETAILS, AND GET READY TO TRACE YOUR LINES WITH YOUR FELT TIP PEN.

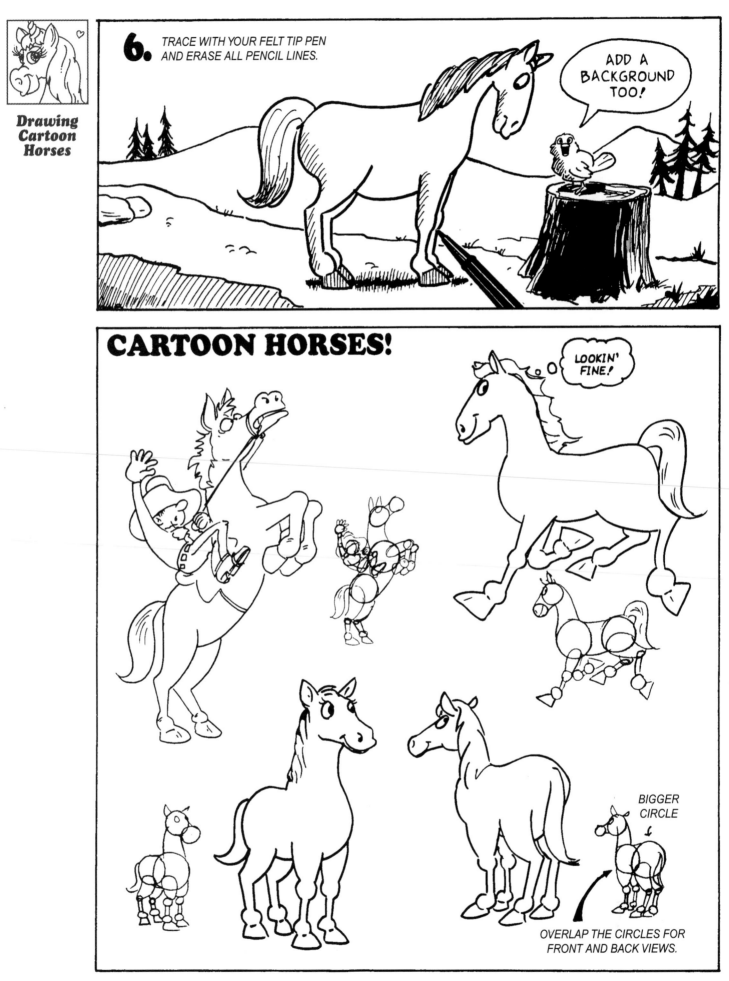

IDEAS FOR MORE HORSES.

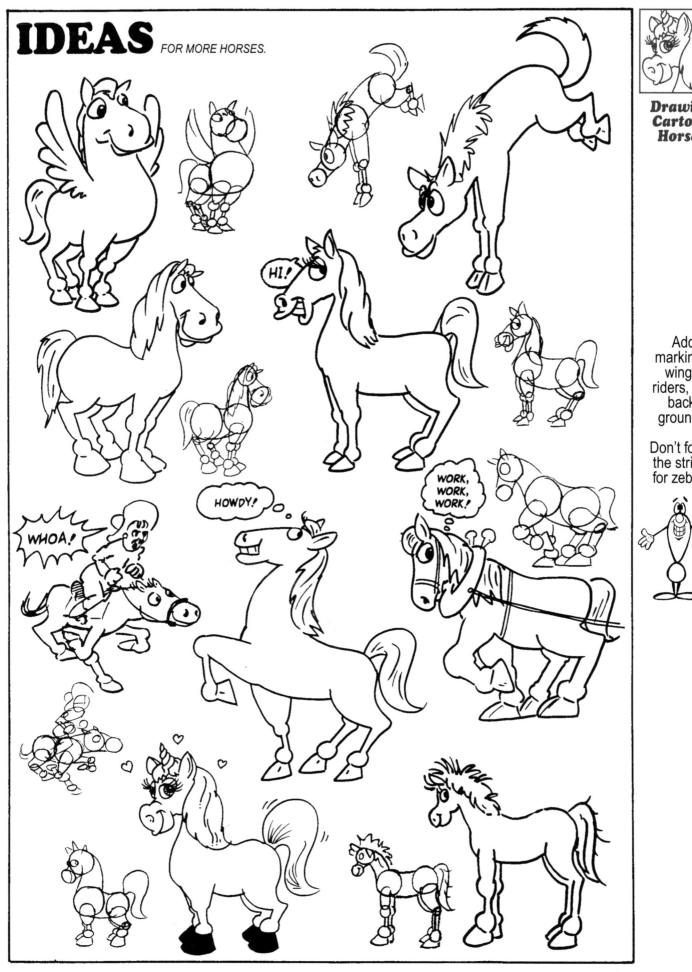

Drawing Cartoon Horses

Add markings, wings, riders, and backgrounds.

Don't forget the stripes for zebras!

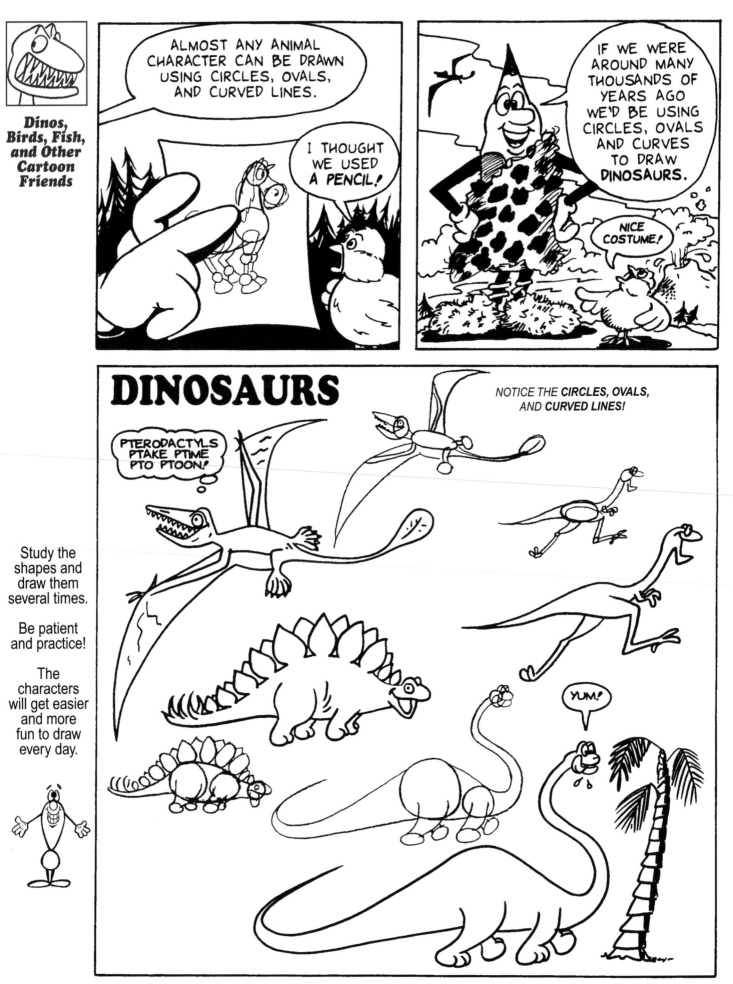

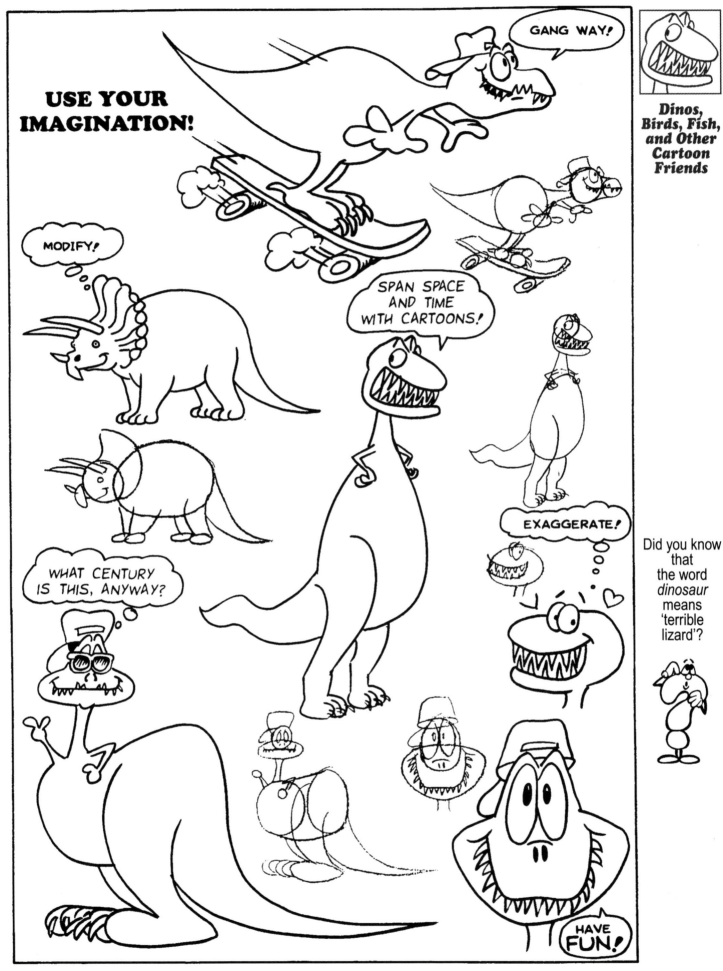

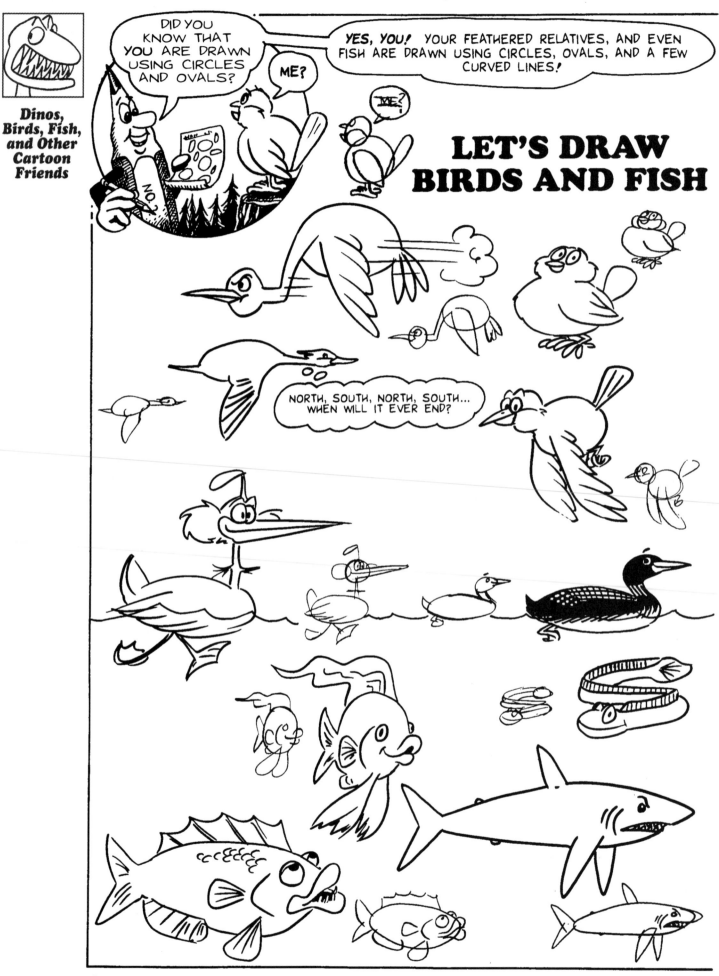

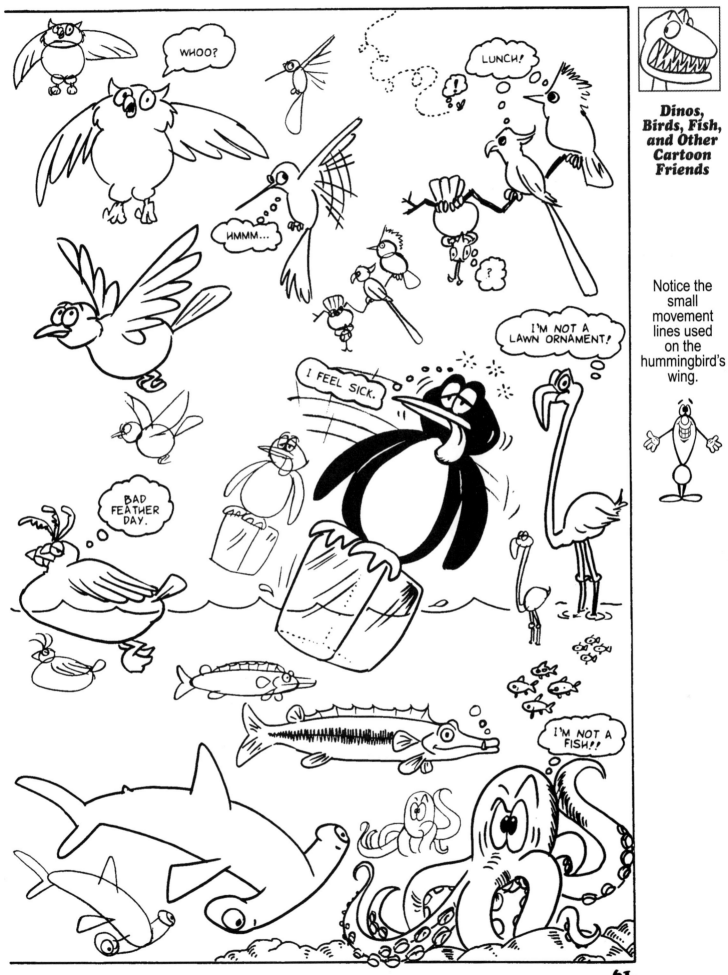

Notice the small movement lines used on the hummingbird's wing.

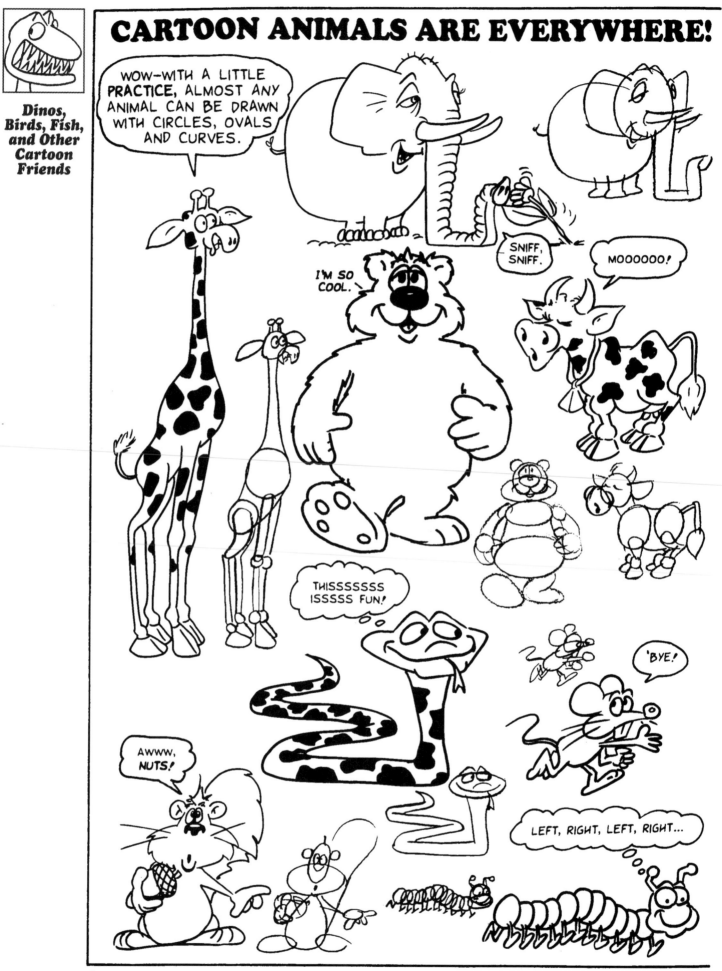

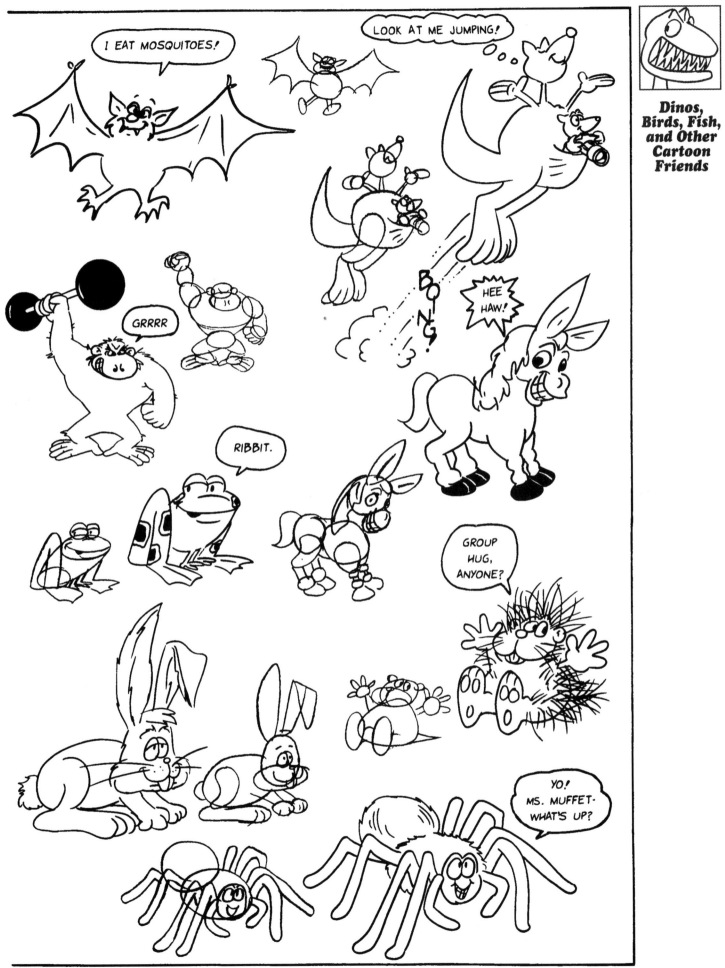

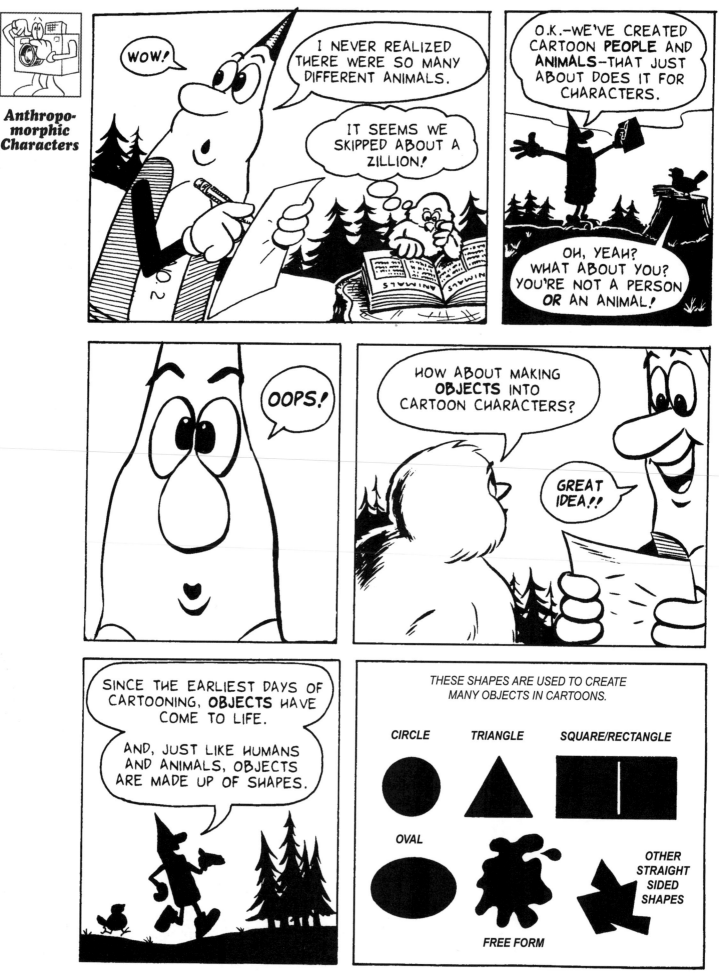

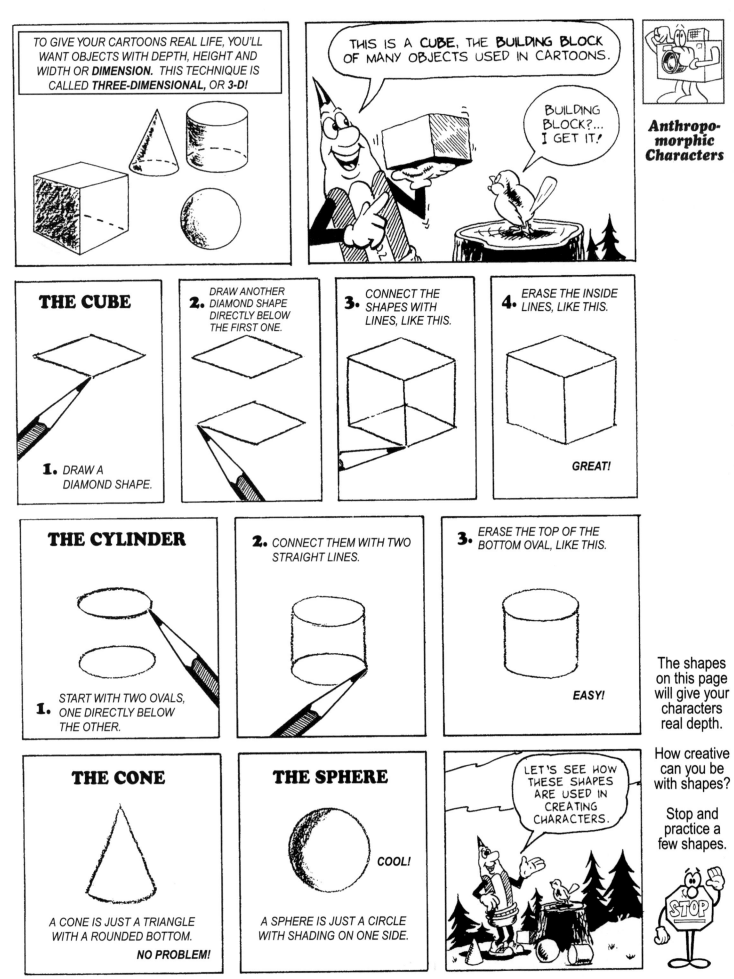

TO GIVE YOUR CARTOONS REAL LIFE, YOU'LL WANT OBJECTS WITH DEPTH, HEIGHT AND WIDTH OR **DIMENSION.** THIS TECHNIQUE IS CALLED **THREE-DIMENSIONAL,** OR **3-D!**

THIS IS A **CUBE,** THE **BUILDING BLOCK** OF MANY OBJECTS USED IN CARTOONS.

BUILDING BLOCK?... I GET IT!

Anthropomorphic Characters

THE CUBE

1. DRAW A DIAMOND SHAPE.

2. DRAW ANOTHER DIAMOND SHAPE DIRECTLY BELOW THE FIRST ONE.

3. CONNECT THE SHAPES WITH LINES, LIKE THIS.

4. ERASE THE INSIDE LINES, LIKE THIS.

GREAT!

THE CYLINDER

1. START WITH TWO OVALS, ONE DIRECTLY BELOW THE OTHER.

2. CONNECT THEM WITH TWO STRAIGHT LINES.

3. ERASE THE TOP OF THE BOTTOM OVAL, LIKE THIS.

EASY!

The shapes on this page will give your characters real depth.

How creative can you be with shapes?

Stop and practice a few shapes.

THE CONE

A CONE IS JUST A TRIANGLE WITH A ROUNDED BOTTOM.

NO PROBLEM!

THE SPHERE

COOL!

A SPHERE IS JUST A CIRCLE WITH SHADING ON ONE SIDE.

LET'S SEE HOW THESE SHAPES ARE USED IN CREATING CHARACTERS.

ANTHROPOMORPHIC CHARACTERS

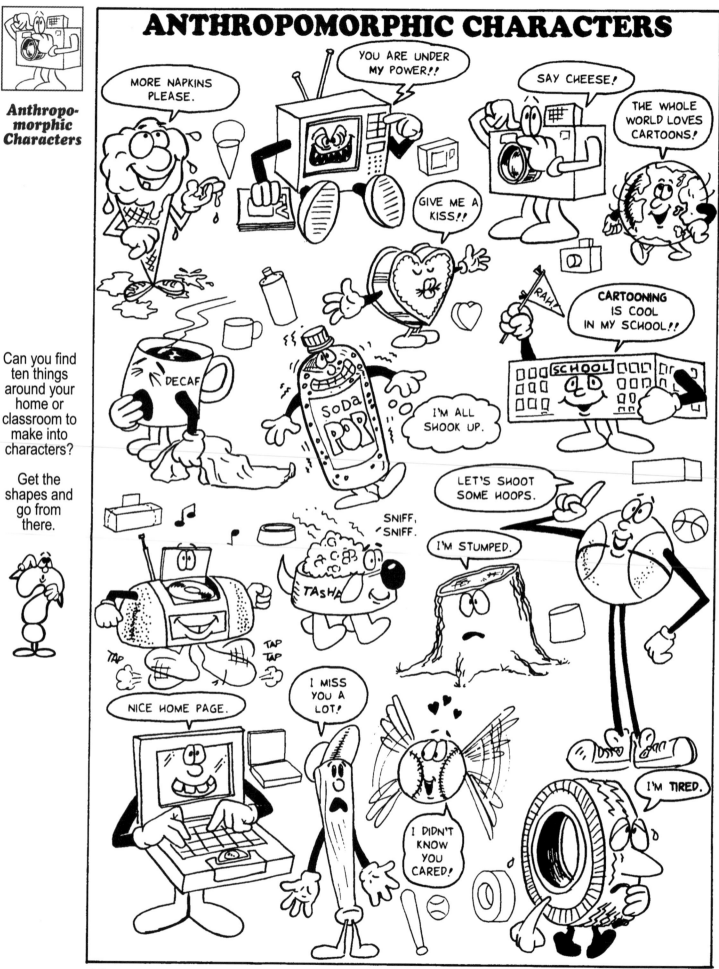

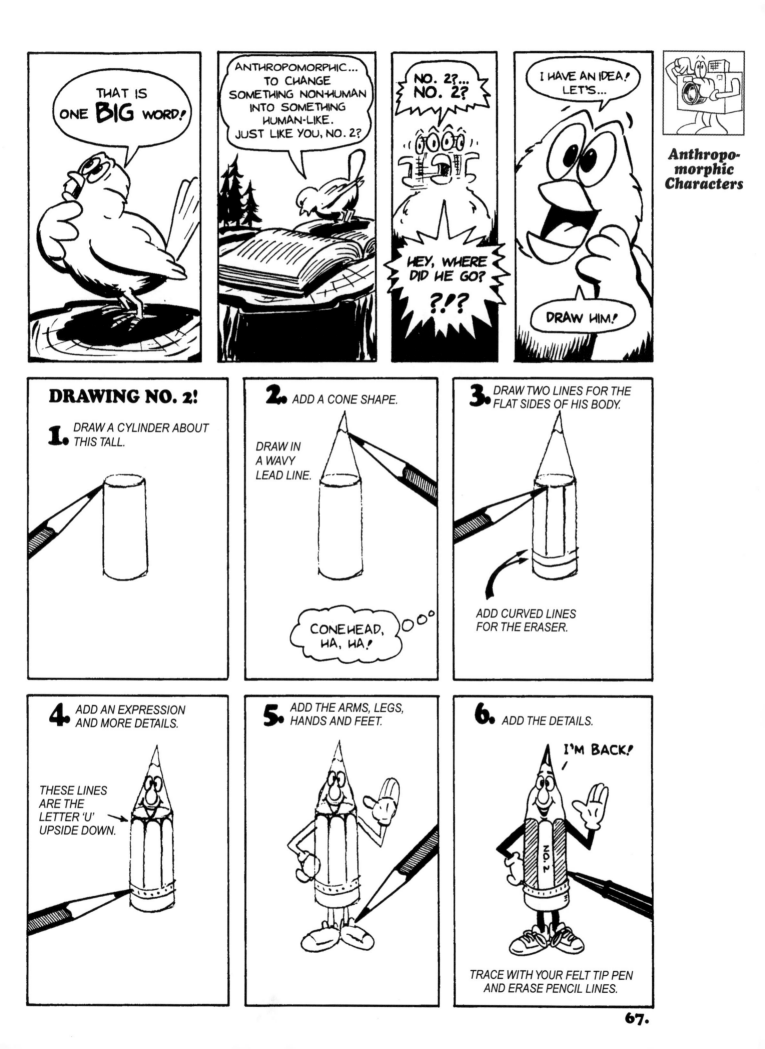

THAT IS ONE **BIG** WORD!

ANTHROPOMORPHIC... TO CHANGE SOMETHING NON-HUMAN INTO SOMETHING HUMAN-LIKE. JUST LIKE YOU, NO. 2?

NO. 2?... NO. 2?

HEY, WHERE DID HE GO? ?!?

I HAVE AN IDEA! LET'S...

DRAW HIM!

DRAWING NO. 2!

1. DRAW A CYLINDER ABOUT THIS TALL.

2. ADD A CONE SHAPE.

DRAW IN A WAVY LEAD LINE.

CONEHEAD, HA, HA!

3. DRAW TWO LINES FOR THE FLAT SIDES OF HIS BODY.

ADD CURVED LINES FOR THE ERASER.

4. ADD AN EXPRESSION AND MORE DETAILS.

THESE LINES ARE THE LETTER 'U' UPSIDE DOWN.

5. ADD THE ARMS, LEGS, HANDS AND FEET.

6. ADD THE DETAILS.

I'M BACK!

TRACE WITH YOUR FELT TIP PEN AND ERASE PENCIL LINES.

67.

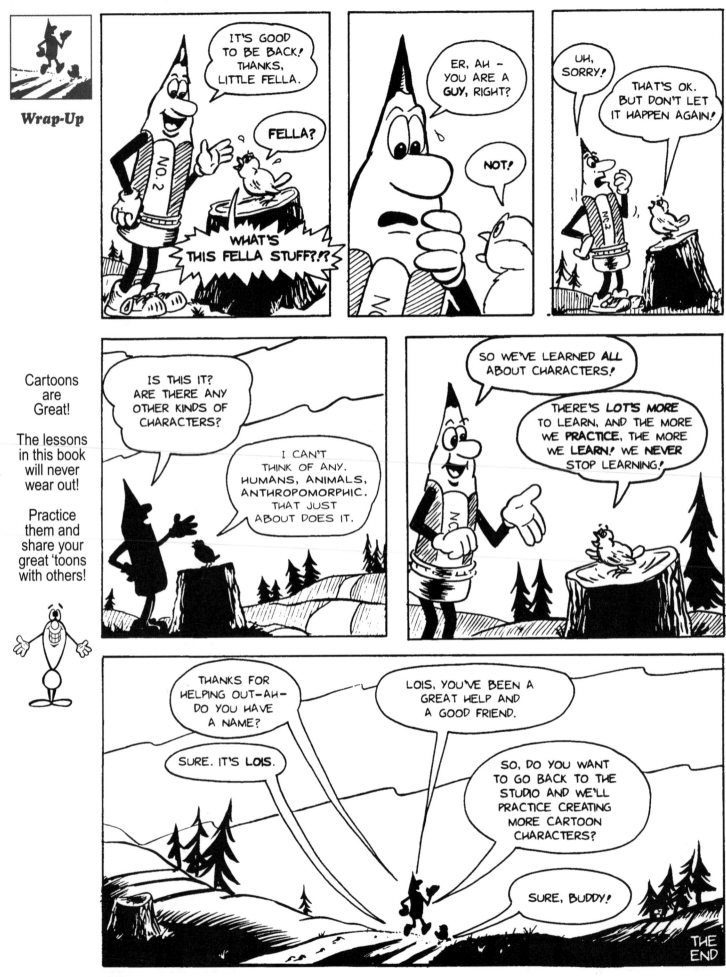

NO. 2'S TOP TEN 'TOON TIPS

1. BE PREPARED. HAVE MATERIALS HANDY. DON'T RUN OUT OF PAPER OR SHARP PENCILS WHEN THE MOOD TO 'TOON STRIKES.

2. LEARN FROM THE PRO'S. LOOK AT CARTOON STRIPS AND CARTOON BOOKS CREATED BY ARTISTS WHO REALLY KNOW HOW TO DRAW AND HOW TO MAKE THEIR STORIES INTERESTING. DON'T FOLLOW THE CROWD WITH THE LATEST FAD CARTOON UNLESS IT IS WELL DONE.

3. USE THE LIBRARY! LIBRARIES HAVE ZILLIONS OF IDEAS. FIND TIME TO "SURF THE SHELVES" FOR PICTURES AND IDEAS.

4. VISIT CARTOON EXHIBITS, MUSEUMS, AND STUDIOS. EXAMINE ORIGINAL ART DRAWN BY CARTOON MASTERS JUST AS ANY OTHER ARTIST WOULD EXAMINE THE ARTWORK OF THE MASTERS OF FINE ART.

5. COPY YOUR CARTOONS AND SHARE THEM WITH FRIENDS AND FAMILY. KEEP YOUR ORIGINAL CARTOONS IN A SAFE PLACE, STORED FLAT, NOT FOLDED OR ROLLED. IF YOU SAVE YOUR ORIGINAL DRAWING, YOU CAN ALWAYS MAKE MORE COPIES.

6. DON'T STEAL OTHER CARTOONISTS' CHARACTERS AND CALL THEM YOURS. IT IS NOT ONLY ILLEGAL, IT ROBS *YOU* OF THE SATISFACTION OF CREATING YOUR OWN CHARACTERS AND CAN PROVE TO BE EMBARRASSING.

7. MAKE A MORGUE. A MORGUE IS A COLLECTION OF PICTURES CLIPPED FROM MAGAZINES AND NEWSPAPERS. THESE REFERENCES SHOULD BE KEPT IN FOLDERS OR ENVELOPES WITH SUBJECT HEADINGS SUCH AS *PEOPLE, COSTUMES, SCENERY, ANIMALS,* OR *WHATEVER* INTERESTS YOU. WHEN YOU WANT TO DRAW A CERTAIN OBJECT OR COSTUME, YOU MIGHT FIND IT IN YOUR MORGUE.

8. PRACTICE EVERY DAY. IT IS EASY TO GET BUSY AND NOT HAVE TIME TO DRAW. BUT JUST LIKE SPORTS, IF YOU DON'T PRACTICE, YOUR SKILLS SLIP AWAY. A FEW MINUTES OF DRAWING EACH DAY WILL IMPROVE YOUR SKILLS AND KEEP THEM SHARP. SOON YOU'LL LOOK FORWARD TO YOUR DAILY 'TOON TIME.

9. DON'T BE AFRAID TO REDRAW A CARTOON. REDRAW IT UNTIL YOU GET IT THE WAY YOU WANT IT. IF YOU ARE TRYING SOMETHING DIFFICULT, HAVE PATIENCE AND CONFIDENCE THAT YOU'LL GET IT WITH PRACTICE.

10. TAKE CLASSES IN CARTOONING AND RELATED FIELDS. SOME COMMUNITIES DON'T HAVE CARTOONING INSTRUCTORS, SO TAKE CLASSES IN DRAWING AND WRITING. SOME CARTOONISTS ACTUALLY TAKE ACTING CLASSES SO THEY CAN POSE THEIR CHARACTERS BETTER. SUPPORT YOUR LOCAL ARTS ORGANIZATIONS, AND ENCOURAGE THEM TO ADD CARTOONING TO THEIR CLASS LINEUP IF THEY DON'T HAVE IT ALREADY.

HAPPY 'TOONING!

INDEX

LOOK IT UP!

SSSSUPER!

GLOSSARY

ADVERTISING CARTOON
A cartoon that is used to sell a product or service.

ANIMATION
Many cartoon drawings shown rapidly giving the illusion of movement.

ANTHROPOMORPHIC
A non-human object or animal which takes on the characteristics of a human.

BALLOON
An area where the words and thoughts of cartoon characters are written.

CARTOON
A simple drawing, often makes us laugh by telling a funny story. Cartoons are found – well, see page 4.

CARTOONING BASICS
Beginning cartooning skills. Also name of this book. Have fun using *Cartooning Basics*.

CARTOONIST
A person who loves to draw cartoons, like you!

CHARACTERS
The 'actors' in cartoons.

CIRCLE
A very round shape. Look at a penny.

COMIC BOOK
A small book which tells a story using cartoons.

COMIC STRIP
A cartoon which appears on a regular basis; weekly, daily, or monthly using multiple panels. Usually in newspapers and magazines.

COPIER PAPER
Paper used in a copy machine. White is best for cartooning.

COSTUME
The clothing worn by a cartoon character. Usually helps us know more about that character.

EDITORIAL CARTOON
A cartoon that makes us think about serious or interesting events that are current topics in the news.

ERASER
A soft piece of rubber which allows us to erase unwanted pencil lines after our cartoons have been traced with a felt tip pen.

EXPRESSION
Showing feelings and emotion, especially on faces.

FELT TIP PEN
A pen which gives a nice, black line but doesn't smudge after it's dry.

GESTURE DRAWING
Giving great action to our characters' bodies by using interesting stick figures.

GLOSSARY
An area usually in the back of a book which defines terms and references used in the book.

GUIDELINES
Erasable lines used for positioning a character's body and parts of the face.

HEAD
The thinking, seeing, smelling, eating, hearing part of our bodies. Also a unit of measurement for drawing the height of our cartoon characters.

JOINTS
The parts in our bodies that can bend, like elbows, hips, knees, neck, and knuckles.

MORGUE
An organized box or other container used by artists to keep reference pictures for future drawings.

MUGGING
Making faces at ourselves in the mirror so we can draw those expressions on our cartoon characters.

THIS GLOSSARY EXPLAINS SOME OF THE WORDS IN THIS BOOK, DEARS!

NO. 2
A pencil used in schools. Also the name of the main character this book. No. 2 takes us step-by-step through some great cartooning exercises and fun.

NUMBER 2
Same as No. 2.

OVAL
A squashed circle.

OVERLAP
Positioning one shape over another so that one peeks out from behind the other. Example: overlapping a circle and an oval.

PENCIL
One of the essential tools used by cartoonists. Made of wood with a graphite core. Use it everyday to make fun cartoon characters upon paper.

'PRACTICE MAKES PERFECT!'
An old saying that is as true today as it was when it was first spoken. The more we practice, the better we will get at doing whatever it is that we want to be good at.

PROFESSIONAL CARTOONIST
An artist who earns money by drawing cartoons. Often called a 'pro'.

PROFILE
A side view. On humans you will only see one ear. See cartoon of the nice lady at the top of this page!

ROUGHING-IN
A technique used to fill in the fat and muscle over the stick figure of a cartoon character. Very important! See pages 32-33.

STICK FIGURE
The 'skeleton' of a cartoon character. Very important! An active stick figure will make an exciting start to a great character! You'll find them on pages 26-37.

TELEVISION
A wonderful, entertainment invention. Should be used in moderation to avoid addiction.

TRACE
Copying a drawing by following the lines as seen through a transparent paper. Going over a pencil line with a felt tip pen.

TRANSITIONS
Going from one subject to another. *Gets better with practice.*

THREE-FOURTHS
Turning the cartoon head so it's seen from an angle.

THREE-QUARTERS
Same as three-fourths view.

3/4 VIEW
Same as three-fourths view.

WARM-UP EXERCISES
Quickly sketching circles, ovals and curved lines to prepare our hands and minds for some great cartooning!

ZOETROPE
A nineteenth century animation machine. By placing a series of drawings inside and by spinning the machine, the illusion of movement delighted every viewer.

GREATBOOKS AND PLACES FOR *INFORMATION* AND *FUN!*

CHECK IT OUT!

BIBLIOGRAPHY

Finch, Christopher, *The Art of Walt Disney: from Mickey Mouse to the Magic Kingdom,* Harry N. Abrams, Incorporated, New York, 1995.

Waugh, Coulton, *The Comics,* University Press of Mississippi, Jackson & London, 1947.

Lee, Stan and Buscema, John, *How to Draw Comics the Marvel Way,* A Fireside Book, Simon & Schuster, Inc., New York, 1984.

Horn, Maurice. (ed.), *The World Encyclopedia of Comics,* Chelsea House Publishers, New York, 1976.

Richardson, John Adkins, *The Complete Book of Cartooning,* Prentice-Hall, Inc., New Jersey, 1977.

Waid, Mark. (intro.), *Superman in Action Comics,* Abbeville Publishing Group, New York, 1993.

Wilson, Marjorie, and Brent Wilson, *Teaching Children to Draw, a Guide for Teachers & Parents,* Prentice-Hall, Inc., New Jersey, 1982.

SUGGESTED READING FOR MORE FUN!

Funny Pictures: Cartooning with Charles M. Schulz, by Charles M. Schulz, Peanuts Interactive Books, Published by Harper Collens Juvenile Books, San Francisco.

How to Animate Film Cartoons, by Preston Blair, Walter Foster Publishing, Inc.

How to Draw Animal Cartoons, by Ed Nofziger, Walter Foster Publishing, Inc.

How to Draw Cartoon Animation, by Preston Blair, Walter Foster Publishing, Inc.

How to Draw Cartoon Animation, by Walter Foster, Walter Foster Publishing, Inc.,

How to Draw Comics the Marvel Way, by Stan Lee and John Buscema, A Fireside Book, Published by Simon & Schuster, Inc.

Mark Kistler's Draw Squad, by Mark Kistler, A Fireside Book, Published by Simon & Schuster Inc., New York.

Mark Kistler's Imagination Station, by Mark Kistler, A Fireside Book, Published by Simon & Schuster Inc.

APPENDIX-PLACES TO SEE ORIGINAL CARTOON ART!

Cartoon Art Museum, 814 Mission Street, San Francisco, California 94103, Phone 415-CAR-TOON (227-8666).

Disney World, MGM Studios, Orlando, Florida, Phone 407-W DISNEY (934-7639). *See Disney animators at work as they create the next, great Disney animated film!*

The International Museum of Cartoon Art, Boca Raton FL., Phone. 561-391-2200. *A great place to see original cartoon art. Check out the very first drawing of Mickey Mouse!*

Gallery Lainzberg, 222 Third Street S.E., Suite 200, Cedar Rapids, Iowa 52401, Phone 1-800-553-9995. *America's oldest and largest gallery specializing exclusively in animation art.*

O'Gara's Pub and Restaurant, 164 Snelling Avenue No., St Paul, Minnesota Phone 612-644-3333. *The site of The Family Barber Shop which was owned by Carl Schulz. The family lived upstairs. Here his son, Charles, starts his professional cartooning career.*

Words and Pictures Museum, North Hampton, Massachusetts, 413-586-8545.

DEAR KIDS,

If you draw cartoons, you're already a cartoonist. If you are lucky enough to have your cartoons printed, you're a *published* cartoonist. Cartoons are really fun to draw, but the greatest fun comes when you share them. Make copies of your cartoons and swap the copies with friends and family. Find a 'toon pal and exchange your magnificent creations! Form a cartooning club at your school.

While it's important to share the cartoons, you can also share the techniques you have learned from this book. Teach your friends how to make your favorite characters, and encourage them to teach their friends.

Some people may feel that creating a cartoon is like knowing a magic trick and the magic goes away when you show someone else how to do it. This is wrong! The real magic is made when techniques are shared and everyone creates their own cartooning magic. The world will be a better looking place with all of those magical cartoons!

Share your cartoons and your cartooning techniques. DRAW EVERY DAY! You'll just get better and better!

Happy 'tooning!

DEAR GROWN-UPS,

If you have a young cartoonist around, you know that you don't have to nag them to do their cartooning "homework", or encourage them to draw. It is very important to show a genuine interest in what they are doing. As grown-ups, we are teachers all of the time. When we are enthusiastic about the cartooning of our young cartoonists, they will strive to get better and better. When we criticize the artistic accomplishments of our youngsters, we are teaching that somehow they don't measure up to our expectations and this may be enough to stop them from drawing, or sharing their drawings. Young people are extremely impressionable, and need the support and encouragement of adults.

Ask to see the cartoons your young cartoonist creates, and ask questions about what they have created and how they created it. Encourage them to add "extras", such as backgrounds, and detail to make their story clearer. Help your cartoonist by having magazines and newspapers around for ideas. Encourage trips to the local library to research cartooning styles and story ideas.

If you enjoy art, or even if you haven't tried drawing for a while, take a few minutes to draw along with your young cartoonist on one of the exercises. Perfection is not needed in cartooning. Sometimes a lop-sided crooked line may create the best looking cartoon character!

You may have the rare chance to encourage the next Charles Schulz (creator of *Peanuts)* or Lynn Johnston (creator of *For Better or For Worse).*

I wish you and your young cartoonist great success!

LET US KNOW!

We have tried our best to make this book fun and useable for young cartoonists. We invite teachers, parents and other grownups to use cartooning as an introduction to the wonderful world of art. We would be happy to find ways to improve future editions. If you like what we did, and have any creative ideas about how this book may be used, please let us know. If you have any comments or ideas for improvements or perhaps something we left out, let us know about this, too!

Duane Barnhart is currently working on a series of video tapes which cover the material in this book. Using his experience teaching thousands of children in schools, Duane presents "Cartooning Basics" in a fun, step-by-step, easy to understand, great for the classroom way! If you are interested, please let us know your name and address. We will inform you when the videos are available and how they can be ordered. Happy Cartooning!

Cartoon Connections Press, 1-888-771-DRAW (3729), PO Box 10889, White Bear Lake, MN 55110.

Editor's Note: *"Cartooning Basics" is a fresh, original approach to the basics of cartooning. Any resemblance to ideas, words, or characters (except in the history section) other than our own is unintentional, and purely coincidental.*

ORDERING INFORMATION:

TO ORDER CARTOONING BASICS, CHECK YOUR LOCAL BOOK STORE, OR...

Send Check or Money Order to:
Cartoon Connections Press
PO Box 10889
White Bear Lake, MN 55110

Shipping: Book Rate. Add $3.00 for the first book and $1.00 for each additional book.

Sales Tax: Minnesota residents please add 6.5% sales tax to your order. Allow four weeks for delivery.

Distributed by North Light Books
An imprint of F&W Publications
1507 Dana Avenue
Cincinnati, OH 45207
Phone: 1-800-289-0963
Dealer inquiries welcome. **Thank You!**

A GREAT GIFT IDEA!

ISBN 0-912423-00-5

ARTHRITIS
FOUNDATION

NATIONAL OFFICE
1314 SPRING STREET, N.W.
ATLANTA, GEORGIA 30309
TELEPHONE: 404/872-7100

Information for your patients

The Arthritis Foundation produces educational pamphlets and other materials for patients on the many forms of rheumatic disease. Information is provided about specific diseases, diagnostics, treatments and coping strategies. These pamphlets are especially helpful for patients and their families who want to find out more about their disease. All materials are available from local Arthritis Foundation chapters, and may be purchased in bulk for distribution to patients.

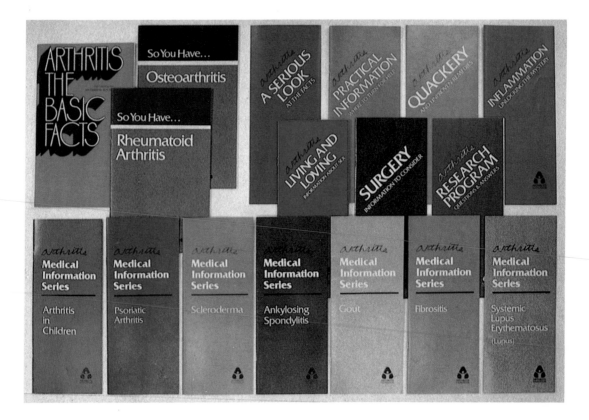

Medical Information Series

Rheumatoid Arthritis
Osteoarthritis
Arthritis in Children
Lupus
Scleroderma
Gout
Ankylosing Spondylitis
Fibrositis

Psoriatic Arthritis
Bursitis & Tendinitis
Back Pain
Reiter's Syndrome
Infectious Arthritis
Polymyalgia Rheumatica
Polymyositis/Dermatomyositis
Pseudogout

Public Education Series

Basic Facts—Answers to Your Questions
Surgery—Information to Consider
Quackery and Unproven Remedies
Practical Information and Where to Turn for Help
Living and Loving—Information about Sex
Diet and Nutrition—Facts to Consider
Inflammation—Unlocking the Mystery

The **Medication Briefs Series** provides descriptions of drugs used in the treatment of rheumatic diseases, dosage information, drug actions, and lists possible side effects. Briefs are available on the following:

Aspirin
Fenoprofen *(Nalfon)*
Ibuprofen *(Motrin, Rufen)*
Indomethacin *(Indocin)*
Meclofenamate *(Meclomen)*
Naproxen *(Naprosyn)*
Phenylbutazone *(Butazolidin)*
Sulindac *(Clinoril)*

Tolmetin *(Tolectin)*
Corticosteroids *(Steroids)*
Hydroxychloroquine *(Plaquenil)*
Penicillamine *(Cuprimine, Depen)*
Methotrexate
Azathioprine *(Imuran)*
Cyclophosphamide *(Cytoxan)*